EDINBURGH
SOUTH SIDE
THROUGH TIME

Jack Gillon & Fraser Parkinson

AMBERLEY

First published 2017

Amberley Publishing
The Hill, Stroud, Gloucestershire, GL5 4EP
www.amberley-books.com

Copyright © Jack Gillon & Fraser Parkinson, 2017

The right of Jack Gillon & Fraser Parkinson to be
identified as the Authors of this work has been
asserted in accordance with the Copyrights, Designs
and Patents Act 1988.

ISBN 978 1 4456 6166 7 (print)
ISBN 978 1 4456 6167 4 (ebook)

British Library Cataloguing in Publication Data.
A catalogue record for this book is available from the
British Library.

Origination by Amberley Publishing.
Printed in Great Britain.

Acknowledgements

We would like to thank Ron Leckie for the use of his images of the Leckie's coal yard, the Leckie coalmen and the Arthur Street coal lorry crash. Thanks also to Ron for his fascinating stories about the South Side. Ron has made his home in California for many years, but has never forgotten his roots in the South Side.

Particular thanks to Calum Mason and Brian McGonagall for access to the roof of Appleton Tower, Joyce Croal for the Southsiders at Play images and George Hunter for the view of Nicolson Street with the Empire Theatre. The colour image of Parker's Stores is credited to the Mathews Collection, courtesy of Douglas Chatham.

Another big thank you is due to Roanna Branigan and James Anderson for the archive image of James Thin's shop on South Bridge.

Huge thanks, as ever, to Emma Jane and Yvonne.

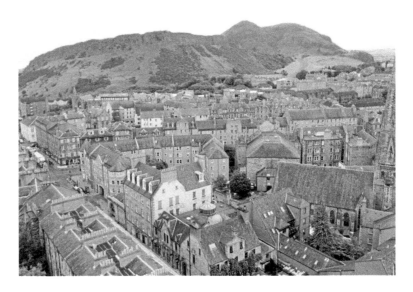

View of the South Side from Appleton Tower.

Introduction

Edinburgh's South Side is one of the most intriguing parts of Edinburgh, with an abundance of historical association and architectural interest. It was, and remains, a close-knit community in which, at one time, there was even a discernible local South Side accent.

In 1766, Edinburgh made its first ambitious expansion beyond the city walls with the development of the architecturally unified George Square. The construction of North Bridge in 1772, followed by South Bridge in 1788, was a major factor in the continuing development of the area.

In the '50s and '60s, the South Side was changed by slum clearance programmes and the expansion plans of the university. Large parts of the area were also blighted by uncertainty over road proposals. The designation of the South Side as a conservation area in 1975 reversed the wave of demolition, and resulted in the regeneration of the area and the retention of much of its historic identity.

Despite the many changes to the South Side, the history, architectural heritage and mix of communities in the area make it one of the most colourful parts of the city, and it holds a unique and special place in the hearts of current and past residents.

The South Side has contributed much to the rich story of Edinburgh. This book highlights just some of the South Side's wealth of historic buildings and the more recent changes that have shaped the area.

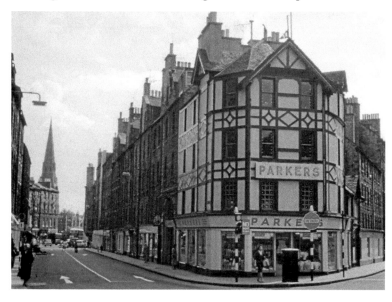

Parker's Stores.

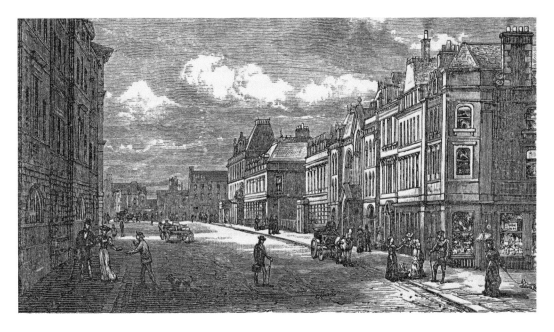

Chambers Street

The 'broad and spacious' Chambers Street was formed in 1871 by the widening of North College Street. The street is named for William Chambers, the Lord Provost of Edinburgh, who was the main promoter of the 1867 Edinburgh Improvement Act. The street was paved with 322,000 wooden blocks in 1876.

In 2016, the layout of Chambers Street was revamped. It included a new pedestrian piazza at the front of the museum with the repositioned statue of William Chambers and a new statue of William Playfair, the architect of many of Edinburgh's landmark buildings.

The development of Chambers Street resulted in the loss of three eighteenth-century squares – Adam Square, Argyle Square and Brown Square.

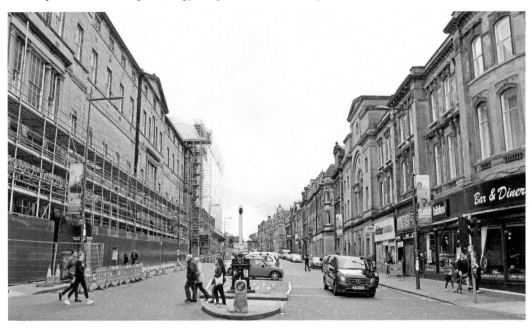

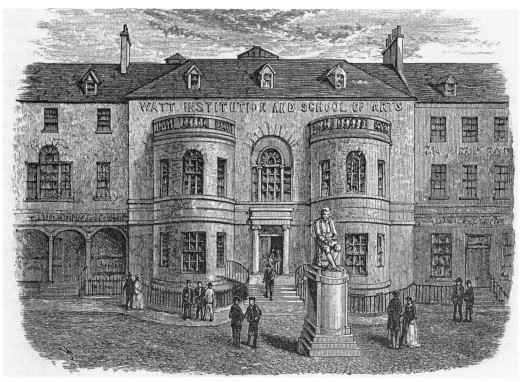

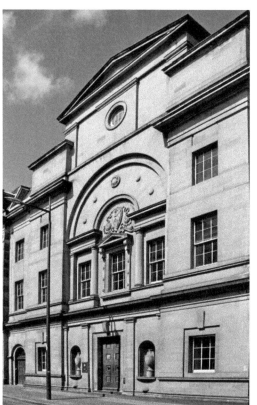

Adam House and Adam Square

Adam Square was close to South Bridge and included two 'handsome houses' with large bow windows. Dr Andrew Duncan, the 'first projector of a lunatic asylum in Edinburgh', was one of the residents. From 1820–72 it housed the School of Arts and Watt Institute, which was founded by Mr Leonard Horner to teach the 'branches of science that would benefit the mechanic'.

The statue in the older image depicts a seated figure of James Watt (1736–1819), the celebrated Scottish engineer and inventor. It was originally unveiled on 12 May 1854 outside of the Adam Square building. The statue was later moved to outside Heriot-Watt College in Chambers Street and in 1991 to Heriot-Watt University's Riccarton Campus.

The Phrenological Museum, which contained a 'carefully assorted collection of human skulls some of great antiquity', stood next to the Watt Institute. The name of Adam House commemorates the eighteenth-century Square. It is in a neoclassical style and perhaps, rather surprisingly, dates from 1954.

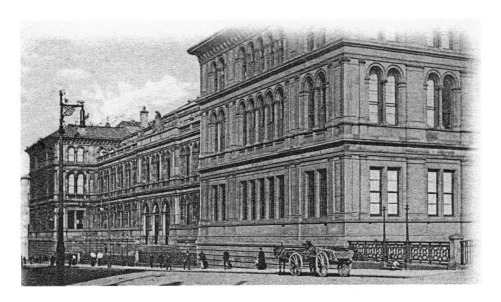

Chambers Street Museum

The foundation stone of the Industrial Museum of Scotland on Chambers Street was laid on 23 October 1861 by Prince Albert – his last public appearance before his death. The building housed a vast collection devoted to natural history, industrial art and the physical sciences. Additions to the building were made in 1874 and 1889. In 1866, it was renamed the Edinburgh Museum of Science and Art, and in 1888 became the Royal Scottish Museum. In 2006, the Royal Scottish Museum was merged with the adjoining Museum of Scotland as the National Museum of Scotland.

Many of the museum's original exhibits were donated by the University of Edinburgh, and there is a bridge over West College Street connecting the museum to the Old College. It seems that students would often use the bridge to pop into the museum to borrow or rearrange the exhibits. At some time in the 1870s, the students procured the museum's store of drinks that had been stored in the bridge and shortly after the entrance to the bridge was closed off.

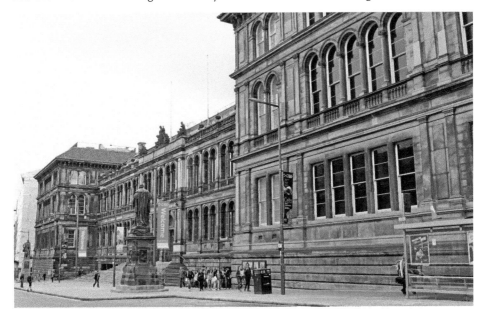

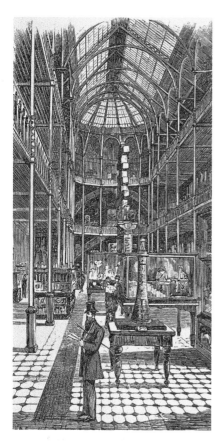

Chambers Street Museum, the Great Hall
The aim of the museum's original architect, Captain Fowkes of the Royal Engineers, who also designed the Royal Albert Hall, was to maximise natural light in the building and the Great Hall has a magnificent glass roof, modelled on the Crystal Palace. The building underwent a major refurbishment and reopened in July 2011 – many locals have since lamented the loss of the fishponds, which were a fondly remembered feature of the Great Hall.

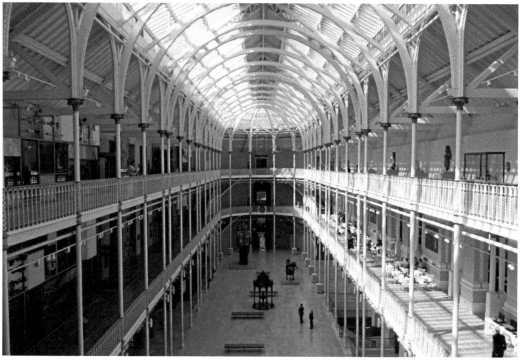

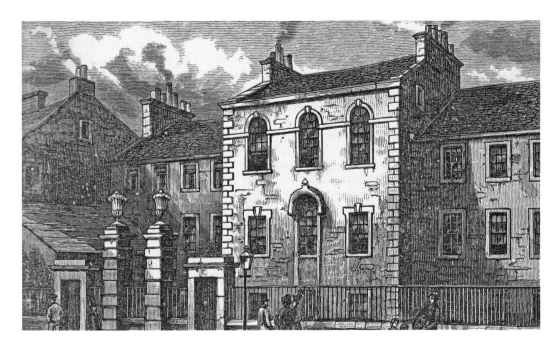

Trades Maiden Hospital and Argyle Square

The Trades Maiden Hospital (*see* above) and Argyle Square (*see* below) were both demolished to make way for the Chambers Street Museum. In 1704, Mary Erskine (1629–1707) endowed the Trades Maiden Hospital, along with the Trades Incorporations of Edinburgh, as a boarding school for the daughters and granddaughters of 'decayed craftsmen and tradesmen'. It was located on the site of the east wing of the present National Museum of Scotland. Mary Erskine had previously established a school for girls, the Merchant Maiden Hospital, which was later renamed the Mary Erskine School. Mary Erskine accrued a minor fortune by running a private bank. In 1794, fifty girls were resident in the Trades Maiden Hospital.

Argyle Square dated from around 1730 and was one of the first terraced housing schemes in Edinburgh. The houses are described as 'massive, convenient and not inelegant'. It is said to have been built by a tailor named Campbell, who had been given early notice of the failing health of George I and made a fortune by cornering the market in black cloth to supply mourning suits at inflated prices.

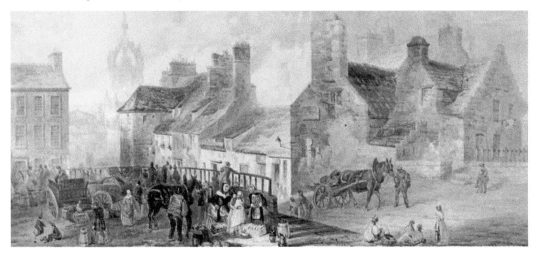

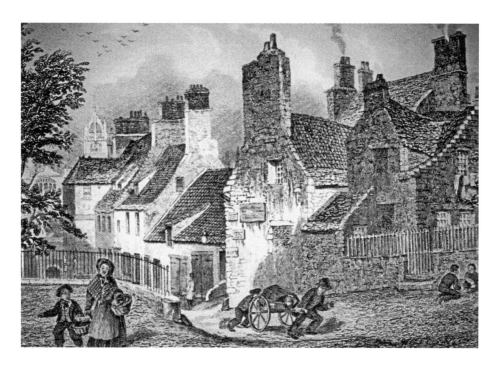

Brown Square

Brown Square was 'a small oblong place about 200 feet east and west by 150 north and south' and included a group of houses called Society. It was developed in 1763 by James Brown, who went on to build George Square. The Square was noted as an 'extremely elegant improvement'. It included a number of stylish mansions and was soon filled with 'inhabitants of a good class' – the Dowager Lady Elphinstone, Viscount Melville, Lord Henderland and Henry Mackenzie, the' Man of Feeling', were among the residents. The south side of Brown Square remained until the 1960s when it was demolished for a museum extension.

The former Museum of Scotland now occupies the site of Brown Square. Opened in 1998, the modernist design of the building was contentious – with no less than Prince Charles objecting to it and resigning as a museum patron.

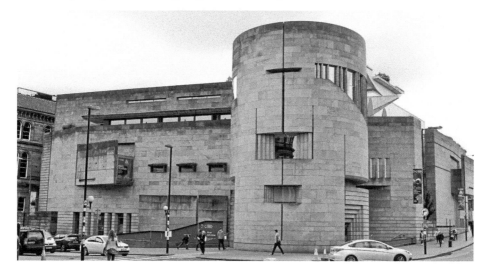

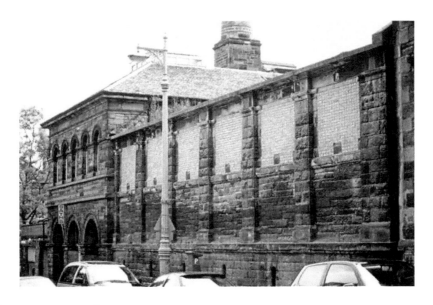

Infirmary Street Baths

The Infirmary Street Baths were designed in an ltalianate style by the city architect Robert Morham, and were built between 1885 and 1887. A feature of the design was the strict physical division of men and women, with separate entrances, stairwells and pools to avoid any contact between the genders. The building originally incorporated hot bath cubicles, laundry facilities, and a gymnasium. Baths and laundry facilities were a rarity in many households at one time, and the plunge baths and laundry at the pool provided welcome personal hygiene options.

In 1960, a fire destroyed the women's pool and damaged adjoining areas. The main pool continued in use until 1995, when the Baths were closed due to water leakage from the pool and the deteriorating condition of the fabric of the building. After the closure of the Baths, they were the subject of a local community campaign to have them restored and reopened. This never happened, and after a long period of closure the building was refurbished and reopened as the Dovecot Tapestry Studio in 2008.

The Baths were constructed on part of the site formerly occupied by the Royal Infirmary building, which opened in 1741 and was demolished in 1884. This replaced the first Edinburgh Infirmary, which opened in August 1729 in a house at the top of Robertson's Close.

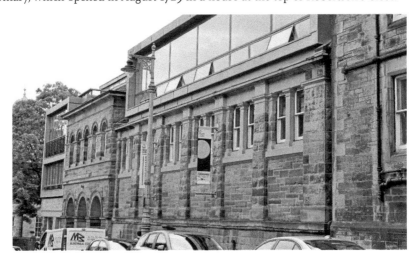

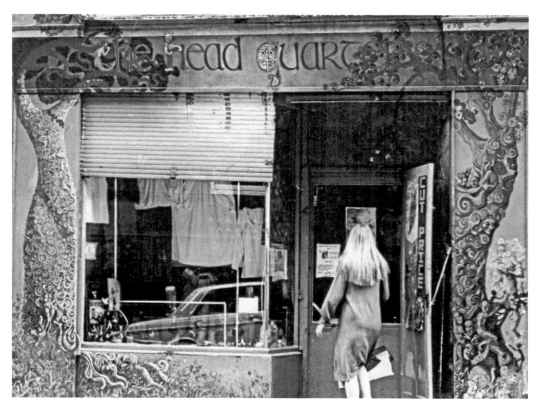

South College Street, the Head Quarter

Groovy man! The far-out Head Quarter shop on South College Street was a haven for South Side hippies – just the place to get your kaftan, Afghan coat, joss sticks and patchouli oil. The record shop in the basement no doubt stocked a wide selection of Incredible String Band records. The psychedelic murals on the shopfront were done by local man and talented artist Kenny Skeel.

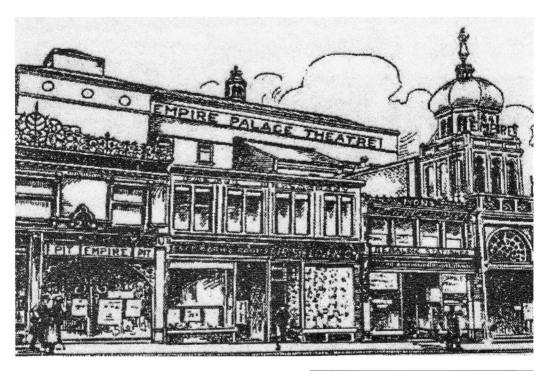

The Empire Palace Theatre, Nicolson Street

The site of the Festival Theatre has been occupied by a bewildering succession of circuses and performance halls since 1830 and is Edinburgh's longest-serving theatre venue. The new Empire Palace Theatre opened on November 7 1892. It was an immensely impressive venue described as 'an edifice of magnificent proportions ... a temple of amusement of a character hitherto unknown in Scotland'. From its opening the theatre featured a diverse blend of the very best in show business of the time.

The creation of the magnificent new theatre was a partnership between two of the great men associated with the theatre – Sir Howard Edward Moss (1852–1912), a major theatre entrepreneur, and the celebrated theatre architect Frank Matcham (1854–1920), nikcnamed 'Matchless Matcham'.

The Empire Palace has a distinguished place in the history of cinema in Scotland as the first venue in the country where moving pictures were shown. The date was 13 April 1896, when cinematography equipment developed by the Lumiere Brothers was used to project animated images during a variety show at the theatre.

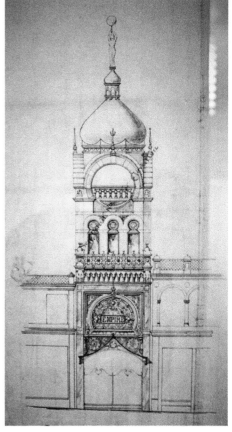

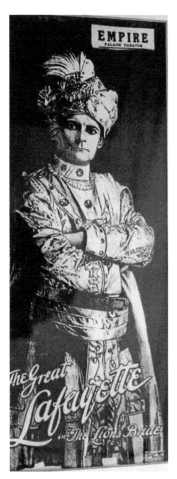

The Great Lafayette and the Empire Palace Fire of 1911

When the Great Lafayette, Sigmund Neuburger, arrived for a two-week season at the Edinburgh Empire Palace in May 1911, he was the most famous magician in the world. Lafayette lived as a bachelor recluse with a small cross-bred terrier named Beauty, which had been given to him by Harry Houdini. The dog slept on velvet cushions, dined at the table with Lafayette and had a collar of pure gold studded with diamonds.

Lafayette's spectacular show opened to packed houses at the Empire Palace on 1 May 1911. On 4 May, Beauty died of apoplexy, caused by overfeeding. Lafayette was grief-stricken and was given permission to have the dog interred at Edinburgh's Piershill Cemetery, with the strict provision that he agreed to be buried in the same place. Meanwhile the show went on. On Tuesday 9 May, as the Great Lafayette took his bow at the end of the show, a lamp fell into the scenery. The fire curtain was lowered and the audience escaped unscathed. However, the backstage was an inferno. There were ten fatalities, including the Great Lafayette.

The streets of Edinburgh were thronged for Lafayette's funeral on 14 May 1911, which was described as 'one of the most extraordinary internments of modern times'. There was great ceremony at the cemetery, as Beauty's coffin was opened and Lafayette's ashes placed beside the dog. The ghost of the Great Lafayette reputedly haunts the theatre to this day.

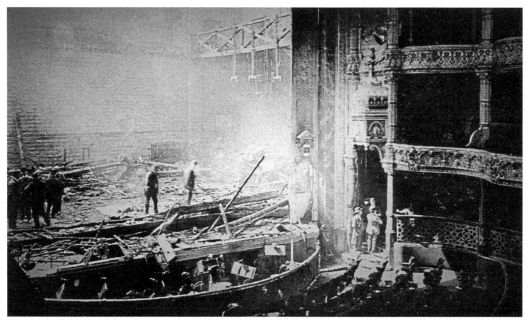

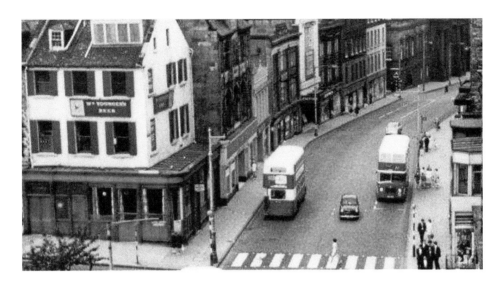

The New Empire Theatre, Nicolson Street

By 1927, the Empire Palace was beginning to look unfashionable and was suffering from the competition from the development of cinemas. In November 1927, the theatre closed and was largely rebuilt to a design by the prominent theatre designers William and Thomas Milburn. The new Empire Theatre (the word Palace was dropped from the name), with its art deco façade, reopened on 1 October 1928.

By the 1950s, the increasing popularity of television meant that it was no longer necessary to leave home for a night's entertainment. This resulted in dwindling audiences for theatres. In 1962, the Empire closed, was sold to Mecca, and by March 1963 reopened as the New Empire Casino to cater for the new fad of bingo.

In 1992, bingo was falling out of favour and Mecca was having financial difficulties. The local authority negotiated the purchase of the building and it was leased to the Edinburgh Festival Theatre Co. The old frontage was replaced with a stunningly modern concave glass and steel façade, which encloses the magnificent 1928 auditorium. The theatre reopened on 18 May 1994 as the Festival Theatre.

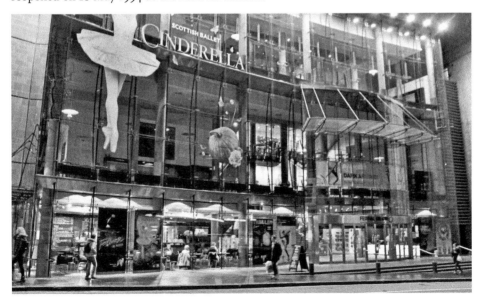

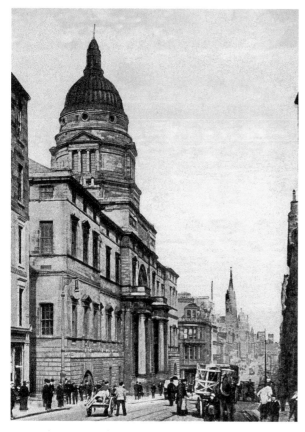

Old College, South Bridge

The Old College is one of the most notable and important academic buildings in Scotland. The foundation stone of the new building for the University of Edinburgh was laid in November 1789. The existing university buildings on the site were in a dilapidated condition and were badly in need of replacement. The design, by the renowned architect Robert Adam, included two internal courtyards. Work began in 1789, but was halted in 1793, with only the north-west corner and main frontage completed, following the death of Adam and the outbreak of the Napoleonic War. A carved-stone panel above the main entrance commemorates 'Architecto Roberto Adam'. In 1818 William Playfair completed the building by retaining much of Adam's design, but with only one large quadrangle.

In 1887, the dome, which had been part of Adam's original design for the college but had been left out as a cost-saving device, was added. The dome is crowned by the *Golden Boy* – a statue of Youth holding a torch and symbolising Knowledge.

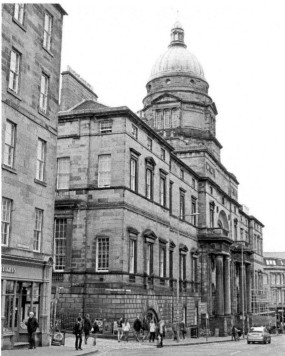

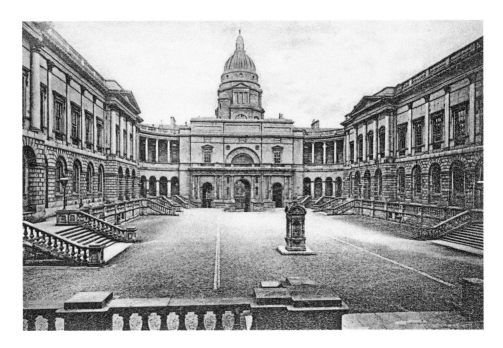

Old College Quadrangle

The magnificent quadrangle at the Old College was re-landscaped in 2010 with a new lawn – in recent years it had been used as a car park.

The site of Old College was the Kirk O' Fields in the 1500s where, in February 1567, Scottish nobles planted barrels of gunpowder with the intention of killing Lord Darnley, the second husband of Mary Queen of Scots, who was lodging in the house.

During the landscaping work at the quadrangle in 2010, the remains of an early library with old scientific equipment, which were believed to have belonged to the eminent chemist Joseph Black, were found.

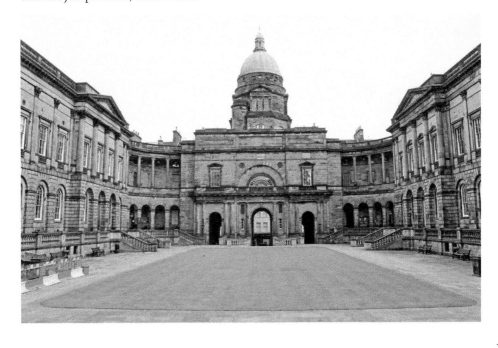

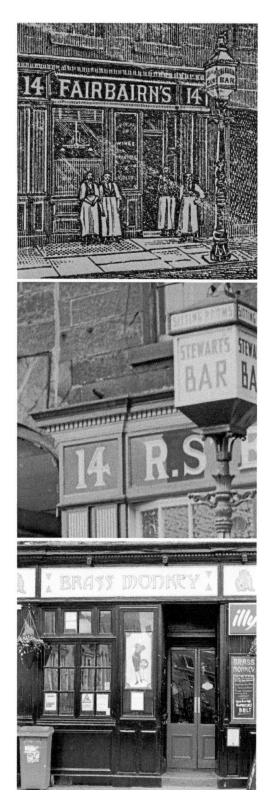

Stewart's Bar/the Brass Monkey,
No. 14 Drummond Street

Stewart's Bar was a long-standing South
Side traditional pub that even had its own
personalised lamp post. It was previously
known as Fairbairn's and now trades as the
Brass Monkey.

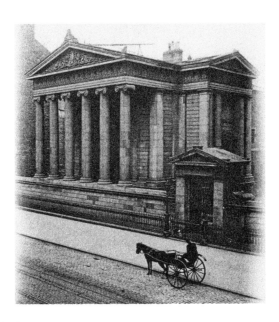

Surgeons' Hall, Nicolson Street

The Royal College of Surgeons of Edinburgh is one of the oldest surgical institutions in the world and has its origins in 1505, when the Barber Surgeons of Edinburgh were formally admitted as a craft guild of the city. In 1647, they established their first permanent meeting place in rooms in a tenement in Dickson's Close. As they expanded, they required a building with an anatomical theatre, and in 1697, they moved into Old Surgeons' Hall in High School Yards. In 1778, George III granted a new charter giving the surgeons' corporation the title 'The Royal College of Surgeons of the City of Edinburgh'.

By the beginning of the nineteenth century, they had outgrown the building and additional space was required for the large collection of pathological specimens, including a full-sized elephant, which had been gifted to the college.

A site on Nicolson Street, occupied at the time by the Royal Academy for Teaching Exercise, a riding school designed by Robert Adam and built in 1764, was acquired. William Henry Playfair, one of the leading architects of the time, was commissioned to design the new building. The Greek Revival-style Surgeons' Hall, with its massive Ionic-columned portico, opened in July 1832.

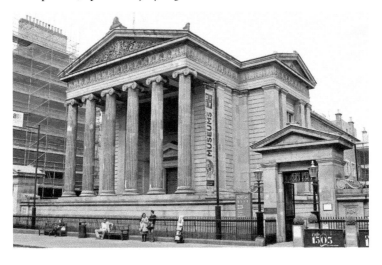

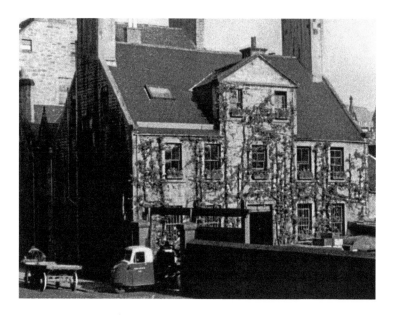

Pear Tree House, West Nicolson Street

The pub takes its name from the old jargonelle pear tree that grows over the main frontage of the building. The house dates from the mid-eighteenth century and the first occupant was Lord Kilkerran, a Court of Session Judge. Lord Kilkerran's son, Sir Adam Ferguson, who was the Member of Parliament for Edinburgh from 1784–90, was the next owner of the house. Sir Adam entertained many eminent celebrities of the time at the house, James Boswell noting in his journal that he 'drank tea at Sir Adam Ferguson's'.

In 1823, the house was purchased by the brewing family of Andrew Usher as a family home and business premises. A room on the second floor has a glass cupola which is a miniature version of the dome of Edinburgh's Usher Hall. Prior to its conversion to a pub in 1982 the building was occupied by J. & G. Stewart, a firm of wine and spirit merchants. The large beer garden, sheltered by a high stone wall, is an added attraction during the summer months when the sun does make an appearance.

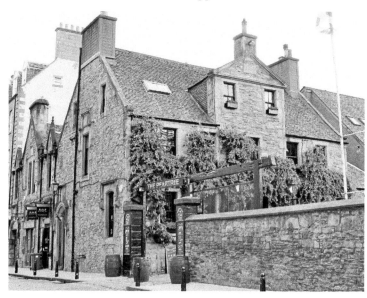

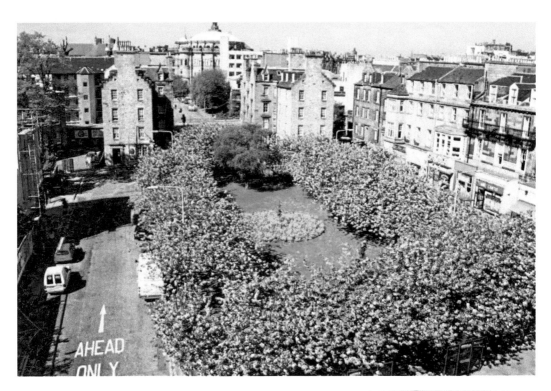

Nicolson Square

The development of Nicolson Square, along with Nicolson Street, dates from 1764 when the city was beginning to expand to the south and the land was acquired from the estate of Lady Nicolson. Nicolson Street was laid out on the axis of Lady Nicolson's house, which stood in the middle of the road at West Richmond Street, and for many years all traffic had to fork around her mansion. After completion of the South Bridge in 1788, the house was demolished.

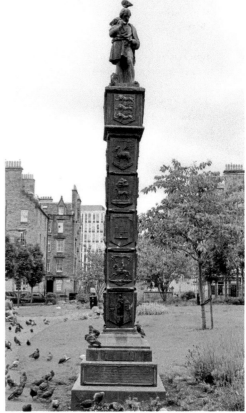

The cherry trees, which are in full luxuriant bloom in the earlier image of the Square, had reached the end of their lifespan when they were removed as part of the refurbishment of the Square in 2008.

The Brassfounders' Column in the gardens was designed by Sir James Gowans as a showpiece for the Brassfounders' Guild of Edinburgh and Leith for the International Exhibition in the Meadows in 1886. The bronze column is decorated with plaques showing heraldic devices and coats of arms. It is topped by a sculpture, by John Stevenson Rhind (1859–1937), of Tubal Cain, the biblical blacksmith who, according to Genesis, was an 'instructor of every artificer in brass and iron'.

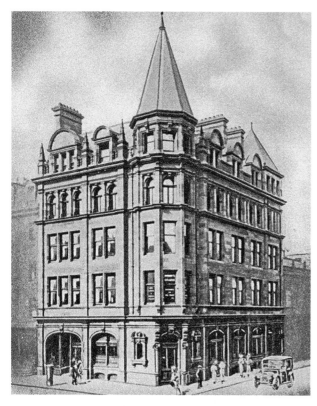

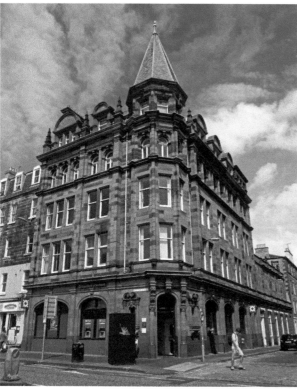

Nicolson Street and Hill Place
This highly decorative and well-detailed red-sandstone tenement on the corner of Nicolson Street and Hill Place dates from 1897–98. It was originally built for the National Bank of Scotland, which was established in 1825 and amalgamated with the Royal Bank of Scotland in 1969. The building also accommodated Edinburgh's Skerry College, which was started by a civil servant, George Skerry, in Edinburgh in 1878. The college ran classes for civil service examinations and grew to have branches in most large cities in Britain. The Skerry College closed for business in June 1970.

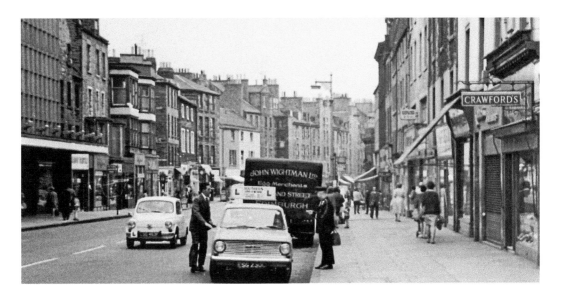

Nicolson Street

It's a busy scene in both of these views, looking south on Nicolson Street. Most of the buildings on the left side of the earlier images were premises of the St Cuthbert's Co-operative Society.

Co-operative societies allowed customers to obtain membership and effectively become stakeholders in the company. Each customer was assigned their own specific five-or-six-digit dividend number, or 'divi'.

Crawford's the bakers was an Edinburgh establishment with shops all over the city. The business first opened in 1899 and finally closed in 1996, when it lost the 'bread wars' with the large supermarket chains.

It looks like the driver of the Southern School of Motoring car in the older image may be having problems with a traffic warden. The first parking meter ever to be seen in Edinburgh was erected for display purposes outside of the City Chambers in October 1960 – they were soon a major feature of the city.

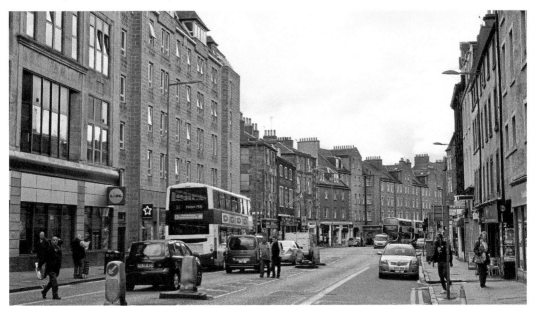

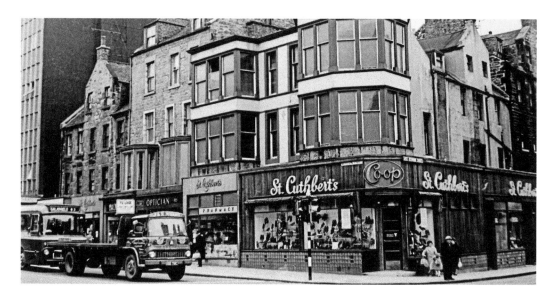

Nicolson Street/West Richmond Street

The picturesque group of buildings, including St Cuthbert's shoe shop and pharmacist, in the earlier image were replaced by a single large block of flats during the course of redevelopment in the South Side.

The first St Cuthbert's Co-op store opened on 4 November 1859 on the corner of Ponton Street and Fountainbridge. 'The Store', as St Cuthbert's was generally known, boasted the highest sales of any co-operative society in the UK, paying out millions in dividends.

In 1944, a thirteen-year-old local Fountainbridge lad by the name of Thomas Sean Connery earned his first wage as a barrow worker at the St Cuthbert's dairy in Corstorphine. If any of the local hyperbole is to be believed, then Sir Sean once delivered milk to almost every household in Edinburgh.

St Cuthbert's changed its name to the Scottish Midland Co-operative Society, or Scotmid for short, in 1981. Milk deliveries by horse and cart came to an end on 26 January 1985, after 125 years' service. Never again would the morning milk delivery be accompanied by the clip-clop of horse's hooves.

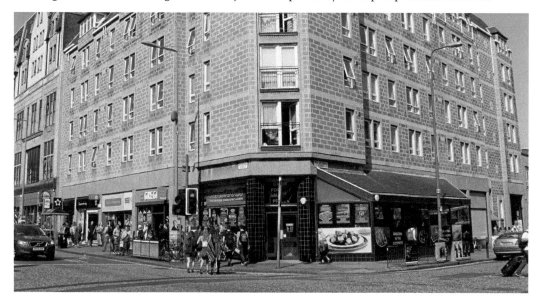

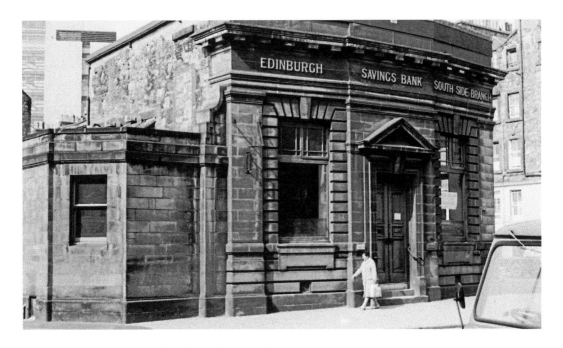

Nicolson Street, Edinburgh Savings Bank

The fine-looking South Side branch of the Edinburgh Savings Bank stood on the corner of Nicolson Street and West Nicolson Street. The Edinburgh Savings Bank opened its first branch in 1870. By 1900, the bank had six branches in Edinburgh and Midlothian, more than 80,000 accounts, and nearly £2¼ million in deposits.

The building was cleared, along with adjoining properties, as part of redevelopment in the South Side. The site stood empty for a number of years and was used as a car park before being redeveloped for housing and shops.

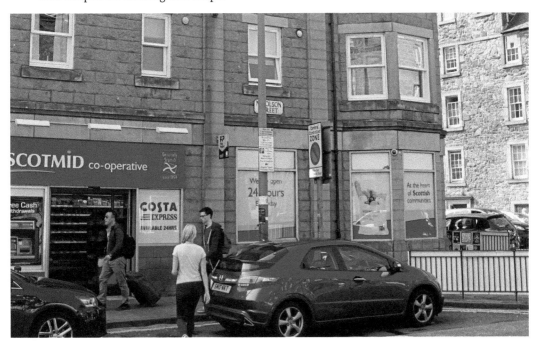

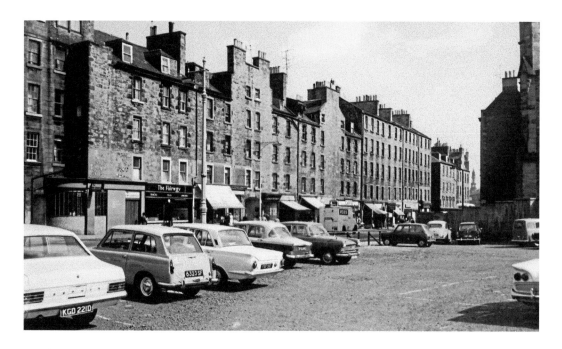

Nicolson Street, Pilot Block I

Proposals by the University of Edinburgh for expansion on the South Side were the cause of much of the redevelopment and blight in the area.

This long block on Nicolson Street, between East Crosscauseway and West Richmond Street, had been acquired in 1960 for a joint project with a development company and the University of Edinburgh. Demolition of the buildings, which dated from the latter part of the eighteenth century, was planned as part of a comprehensive redevelopment scheme. Residents and retailers started to move out and the buildings rapidly deteriorated.

In 1975, proposals for the South Side were rethought, with rehabilitation rather than demolition seen as the way forward. This group of buildings was named the Pilot Block and the project that followed was to mark a new beginning for the South Side.

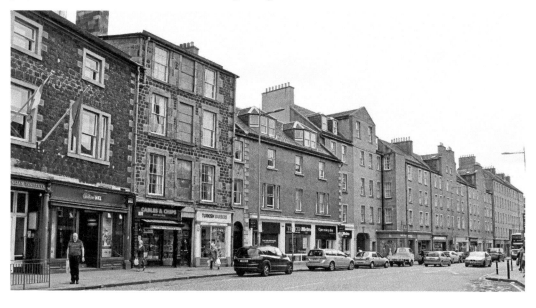

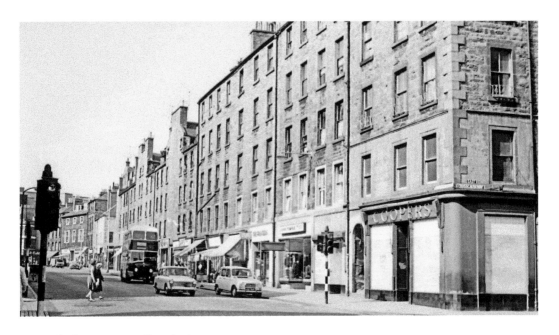

Nicolson Street, Pilot Block II

As part of the Pilot Block project, it was proposed to conserve and restore as many buildings as possible, but buildings that had deteriorated beyond repair were to be replaced in a historic style to preserve the character of the area. The buildings at each end were the least deteriorated and were restored with new buildings between these 'restored bookends'. Funding for the restoration was made available by the Crown Estate Commissioners, who, at the time, were accruing substantial revenue from oil developments.

Work started in December 1978, and was mostly completed by February 1983. The project resulted in sixty-nine flats, a supermarket, twenty-four shops and a pub.

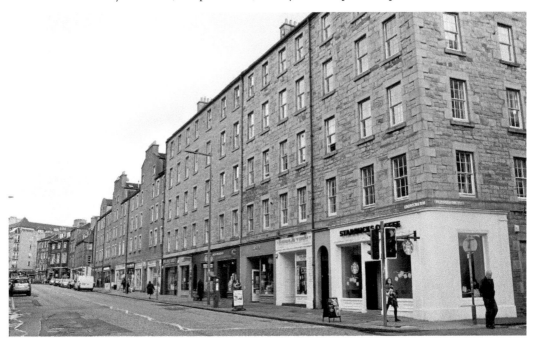

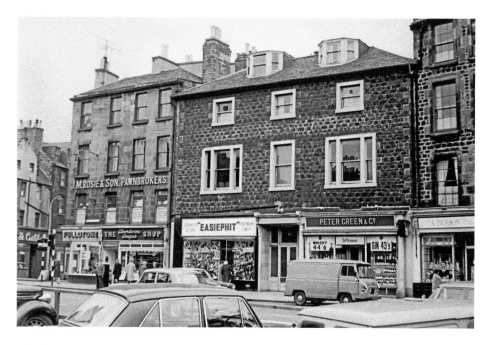

Nicolson Street, Pilot Block III

These buildings at the corner of Nicolson Street and West Richmond Street were preserved and restored as part of the Pilot Block project. The older image is looking over parked cars on the site at the corner of Nicolson Street and West Nicolson Street.

Shops in the earlier image include the Aberdeen Angus Shop and the Easiephit shoe shop. The Peter Green shop has whisky for sale at 44s 6d and gin at 43s 9d – slightly over £2 for both. The shop on the corner in the more recent image continues what seems to be a tradition of pawnbroking in this building.

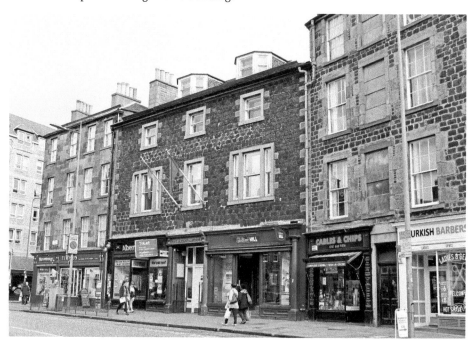

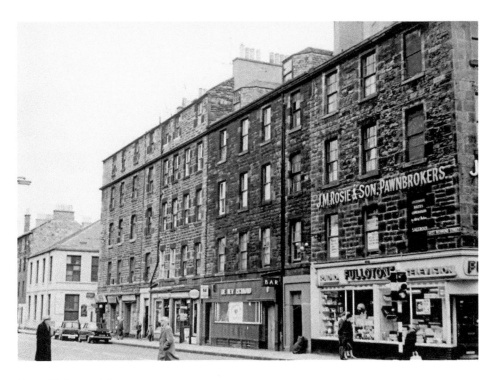

West Richmond Street

This section of West Richmond Street was refurbished as part of the Pilot Block project. Richmond Street was developed before 1773 and was named for James Richmond, who developed the street. The New Richmond pub in the older image is now the Southern Bar.

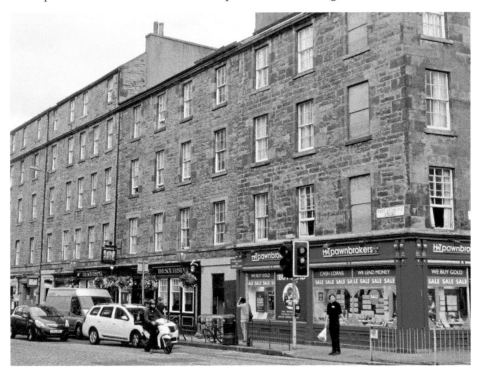

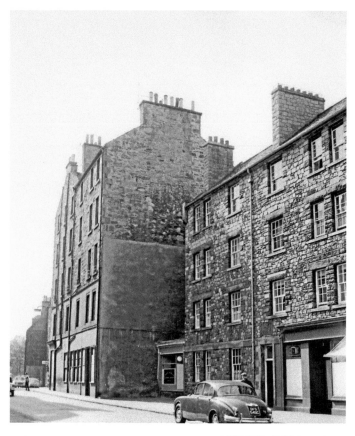

East Crosscauseway

East Crosscauseway was one of the main historic routes in south Edinburgh, linking the old roads to Liberton and Dalkeith. Its early name was the Croce Gait (the cross way). Records show that it was causeyed (laid with stone setts) as early as 1599. Crosscauseway is an anglicized version of Crosscausey.

The single-storey building in the older image was Jeannie Veitch's sweetie shop. Jeannie opened the shop in 1872 and her two daughters ran it after she died in 1953. It was famed among South Side kids for its toffee apples, boilings and fudge. Jeannie also had a second shop in Clerk Street, opposite the New Victoria Cinema (the Odeon).

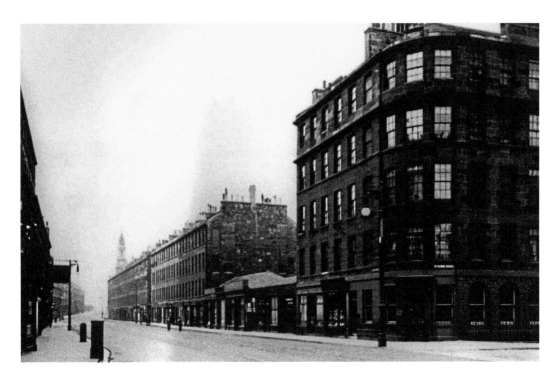

Clerk Street

Looking south on Clerk Street from St Patrick Square. Clerk Street takes its name from William Clerk who was the owner of ground around St Patrick Square. The street was developed with substantial tenements from around 1810 on the estate of Major John Hope. The lower building on the right of the earlier image was demolished to make way for the New Victoria Cinema.

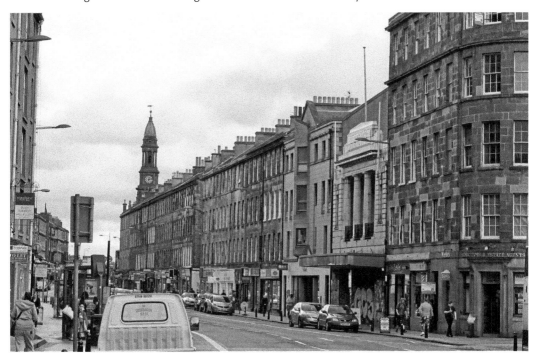

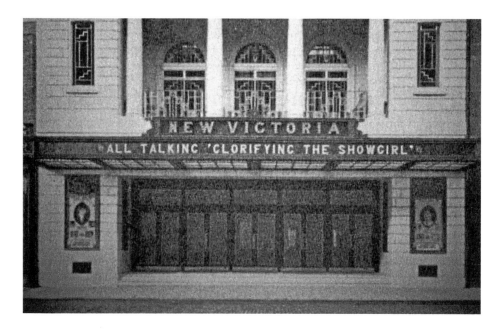

The New Victoria Cinema, Clerk Street

In the heyday of cinemagoing, the South Side could boast numerous local picture houses: the Roxy on Roxburgh Street, the Abbey on Richmond Street, the Lyric and La Scala on Nicolson Street, the Salisbury on Clerk Street, and the Operetta House on Chambers Street.

The biggest and most elaborate was the New Victoria Cinema on Clerk Street. The New Victoria opened on 25 August 1930. It was designed by the prominent cinema architect William Edward Trent and is recognised as an exceptional example of an art deco picture palace.

The name changed to the Odeon in 1964. In August 2003 the cinema closed and was sold to a property developer. There followed a long period of uncertainty about the future of the building. However, at the time of writing, work is proposed to refurbish it for use as a cinema.

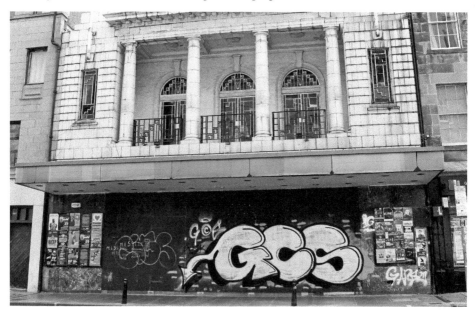

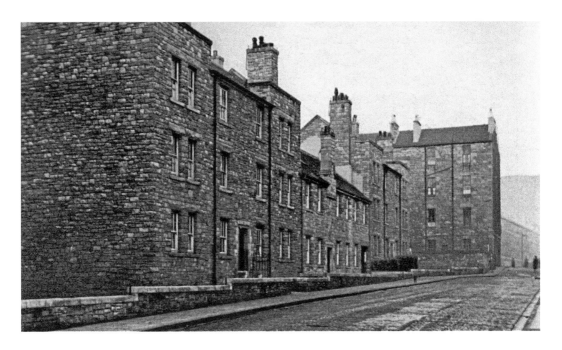

Gifford Park

Gifford Park was part of a scheme, between 1931 and 1938, for rehousing the population living in the South Side. The larger parts of the project were at the Pleasance and Richmond Place. Smaller redevelopments in East Crosscauseway, Buccleuch Street, Simon Square, and St Patrick Square were also carried out at the same time, all adding up to a considerable amount of new housing.

The scheme was prepared by the City Architect's Department under Ebenezer James Macrae. Macrae, was city architect from 1925–46 and was an early promoter of the idea of conservation. He was responsible for numerous interwar council housing schemes, many schools, and the iconic Edinburgh police boxes.

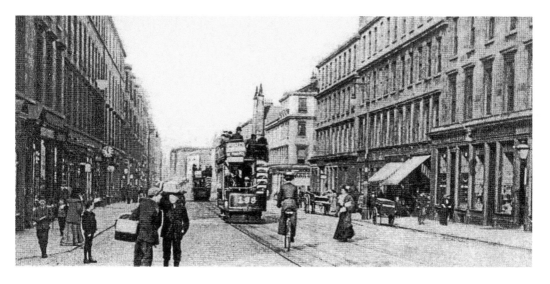

Trams on South Clerk Street

> 'I loved the Edinburgh trams, the yellow slatted wooden seats, the whine and rattle as
> they gathered speed, the driver's low-pitched bell to shoo people out of the way.'
>
> Ludovic Kennedy from his autobiography *On My Way to the Club*, 1990.

Edinburgh's 142-year association with the old trams began in November 1871 when the Edinburgh Street Tramways Co. introduced a 3½-mile horse-drawn line from Haymarket, via Princes Street and Leith Walk, to Bernard Street in Leith. Over the next decade, the popular tram network began to develop into new districts such as Newington. In January 1888, a cable-hauled system was introduced and the tramway was electrified in 1922.

There were significant public protests about the withdrawal of Edinburgh's trams. The final day of the old trams fell on the 16 November 1956. That evening, a grand procession of tramcars paraded from the Braids terminus to Shrubhill depot in Leith. At the Mound an enormous crowd gathered to bid an emotional farewell to a much-cherished thread of the city's colourful fabric. It represented the passing of an era and was an emotional night for the many that had fond memories of the old trams. The new Edinburgh Trams, running between York Place and Edinburgh Airport, opened on 31 May 2014.

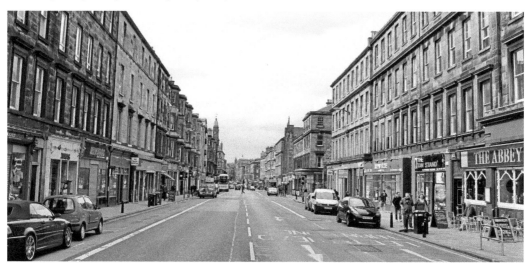

South Clerk Street

These images show South Clerk Street at its junction with Hope Park Terrace and Bernard Terrace. In the older image, the street is decorated with bunting for a visit by Edward VII and Queen Alexandra in May 1903 to commemorate King Edward's Coronation in London the previous year.

The spire of the Queen's Hall is prominent in both images. The Queen's Hall was originally built as the Hope Park Chapel of Ease in 1823. In 1834 it was renamed Newington Parish Church and later Newington and St Leonard's Church. When the buildings closed as a church, it was converted to a music venue and was formally opened by Elizabeth II on 6 July 1979.

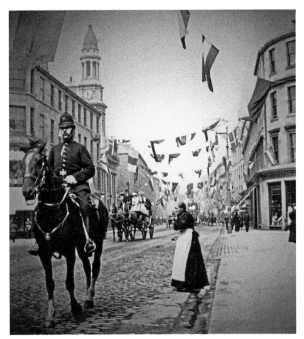

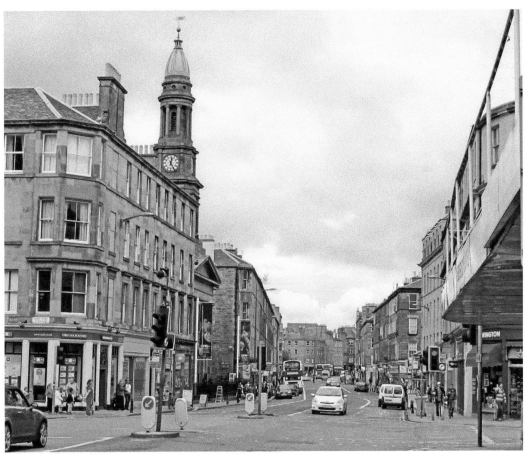

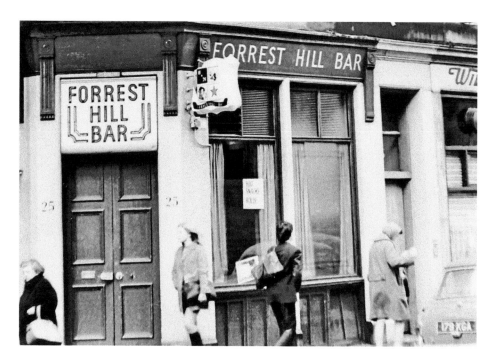

Sandy Bell's, No. 25 Forrest Row

Sandy Bell's started its life as a local grocery shop. By the 1920s it was a pub owned by a Mrs Bell and went by the official name of the Forrest Hill Buffet and later the Forrest Hill Bar, although in recent memory it has always been known as Sandy Bell's – it is likely that Sandy was a barman at Mrs Bell's pub. It has only been since the early 1990s that the signage on the pub has been changed to Sandy Bell's.

Sandy Bell's claim to international fame is its association with the Scottish folk music revival of the 1960s and its continued use as a venue for live music. Jimmy Cairney, the landlord in the 1960s, was a devotee of traditional music. He encouraged young musicians to play in the pub and turned Sandy Bell's into one of the leading folk music venues in Scotland.

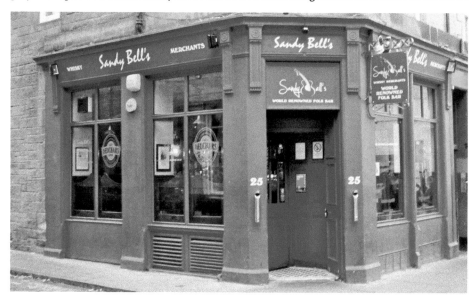

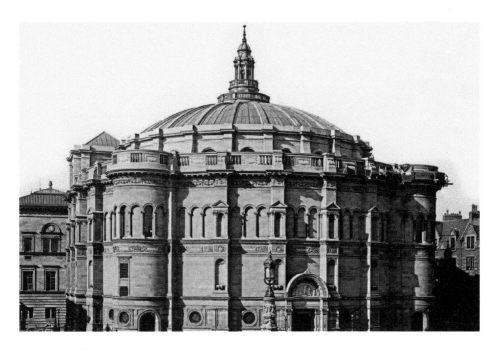

McEwan Hall, Bristo Square

The McEwan Hall was funded by Sir William McEwan (1827–1913), the Edinburgh brewer who established the successful Fountain Brewery in Edinburgh in 1856. McEwan was the Member of Parliament for central Edinburgh and gave £115,000 to the University of Edinburgh to erect a graduation hall.

The design for the building was selected by a competition, and the eminent architect Sir Robert Rowand Anderson was so determined to win that he made a rapid tour of public buildings in England and the Continent before submitting his entry to the competition. Bristo Square, which was laid out in 1983 following the diversion of local roads, provides the setting for the McEwan Hall.

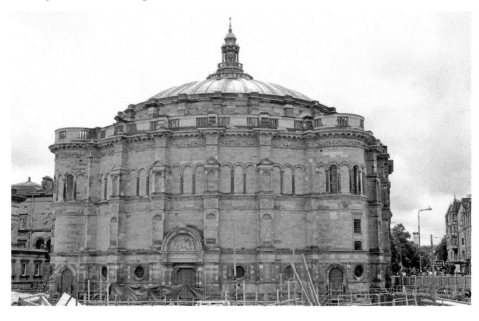

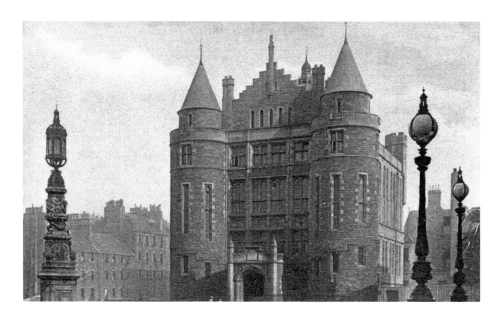

Teviot Row House, Bristo Square

The students of the University of Edinburgh celebrated the opening of Teviot Row House on 19 October 1889 with a torch-lit procession through the city. The students themselves had set out to raise the funds to build the Students' Union, which takes its place in history as the oldest purpose-built Students' Union building in the world.

The original imposing design by Sydney Mitchell & Wilson is influenced by sixteenth-century Scots-Renaissance architecture. The building has been subject of two major extensions over the years – the first was a western extension completed in 1905 and the second a southerly extension added in 1962.

Spirits were only permitted to be sold in the Union from 1970, and in 1971 there was a major constitutional change that allowed women general access to the Union building. Prior to the building of the Union, the site was occupied by Lord Ross' house, which dated from around 1740 and later became a lying-in hospital from 1793 to 1842.

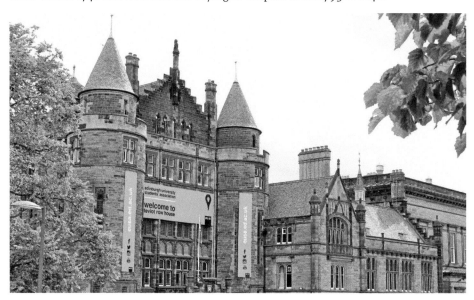

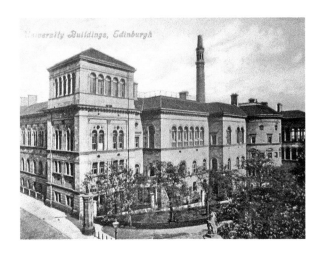

Medical School, Teviot Place

Medicine has been on the curriculum at the University of Edinburgh from the beginning of the sixteenth century. The Medical School was established in 1726 and is one of the oldest in the world. In the 1860s the medical school was within the Old College and by 1880 the new Royal Infirmary had been built on Lauriston Place. The new Medical School, close to the infirmary, was completed in 1888 to a design by Sir Robert Rowand Anderson. Sir Rowand Anderson (1834–1921) was a renowned Scottish architect who was involved with many of the most significant buildings in Scotland.

There have been many eminent alumni of the Medical School over the centuries, including Charles Darwin. Sir Arthur Conan Doyle, who studied medicine at the school from 1876 to 1881, based Sherlock Holmes, his great fictional detective, on the deduction methods of Joseph Bell, a lecturer at the Medical School.

A campanile tower modelled on St Mark's in Venice was proposed but never built. The gate piers at the entrance to Middle Meadow Walk date from around 1850 and are topped by unicorns.

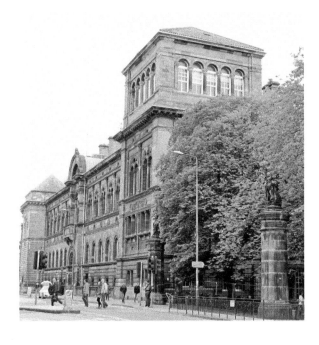

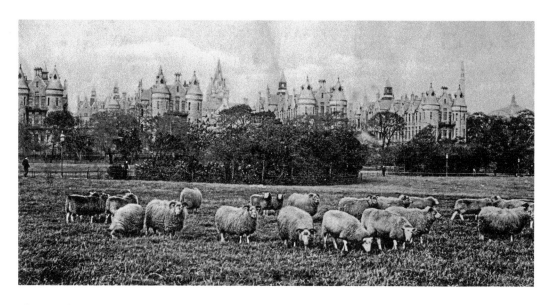

The Meadows

The Meadows was formed by the drainage of the old Borough Loch – which was also known as the South Loch and Straiton's Loch (from John Straiton, who unsuccessfully tried to drain it in 1658). In the sixteenth century it formed the main water supply for Edinburgh, until the level of the water was much reduced by local breweries.

Thomas Hope was responsible for the drainage from 1722. Hope's house, with its distinctive Dutch gable, dates from 1725 and formed the basis of Hope Park Square to the north of the Meadows in the Boroughloch area.

In 1827, an Act of Parliament secured the Meadows for public use. However, it was not until the mid-nineteenth century that it was levelled and paths such as Middle Meadow Walk were laid out. It is now one of the most important and extensive open spaces in the city.

The Royal Infirmary at Lauriston Place, in the background of both images, opened in 1879. It was designed with the advice of Florence Nightingale, who favoured the idea of pavilions. The Royal Infirmary moved to its new location at Little France in 2003 and the site has since been redeveloped as the Quartermile project.

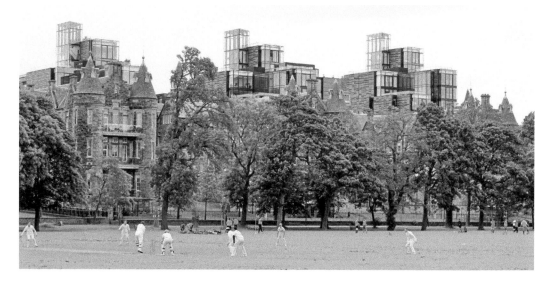

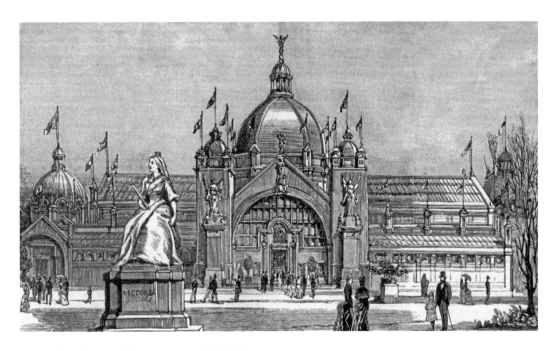

The Edinburgh International Exhibition

30,000 people thronged the Meadows on 6 May 1886 when Prince Albert Victor opened the International Exhibition of Industry, Science and Art. The Exhibition building was an imposing structure comprising a Grand Hall, fronting the main entrance at Brougham Place, with a range of double courts extending eastwards and arranged on either side of a central corridor. The grounds were laid out with numerous other attractions that were lit by 3,200 electric lamps in the largest illumination scheme ever attempted in Scotland. Queen Victoria visited in August 1886. It was originally intended to retain the Grand Hall after the exhibition closed, but an Act of Parliament forbids all permanent buildings within the Meadows, and they were demolished.

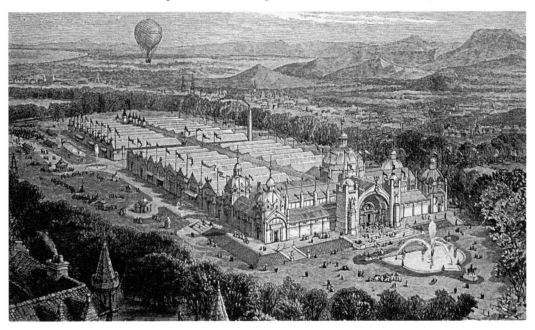

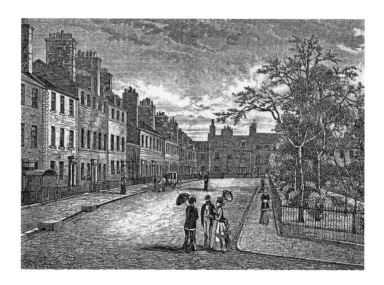

George Square I

After developing Brown Square in the early 1760s, James Brown (1729–1807) drew up plans for George Square – a new development of terraced houses around a central square and the first development of any significant size outside of the overcrowded Old Town. Brown had acquired the site of the Ross Park in 1761 for the development of his 'superior style' houses and the feuing of George Square began in 1776.

It was the earliest and most ambitious scheme of development attempted in Edinburgh and a precursor of the New Town. The scale and unity of its design made it an architectural landmark – it was considered to be one of the finest domestic squares in Europe. The design of terraces with individual houses was a new idea in Edinburgh, where flatted tenements were the norm. The layout of the houses around a central semi-private garden was also a relatively new concept in Scotland.

It was an immediate success and proved popular with Edinburgh's more affluent citizens – No. 25 was the childhood home of Sir Walter Scott. For a time it was the most fashionable residential area in Edinburgh, attracting aristocratic and wealthy families from their cramped houses in the Old Town, but by 1800 it had been eclipsed by the New Town. The square was named after Brown's elder brother, George Brown.

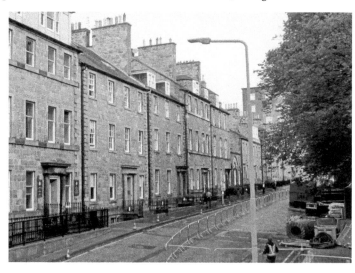

George Square II

By the 1950s, the condition of the buildings in George Square was poor, but, apart from a minor intrusion on the north side, it had retained its original form. The University of Edinburgh promoted plans to integrate the scattered parts of the university and to redevelop George Square, and a wider part of the South Side, as early as 1945. The university believed that the reconstruction of the Square was the only practical solution to its need for expansion.

Fierce debate about the proposals went on throughout the 1950s. Planning permission was granted in 1956, but mounting opposition to the scheme resulted in a public inquiry in 1959. The Historic Buildings Council then indicated that they considered George Square interesting, but not comparable to the quality of Charlotte Square and the technical advice was that they were too dilapidated for reuse. The fate of George Square was sealed and, in the mid-1960s, the redevelopment went ahead. In the face of a public outcry, modernist blocks replaced many of the old Georgian buildings. Now only original portions of the east and west sides remain.

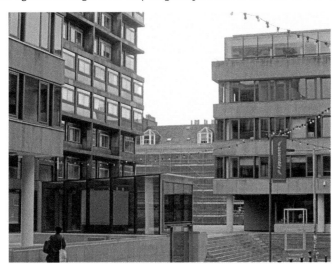

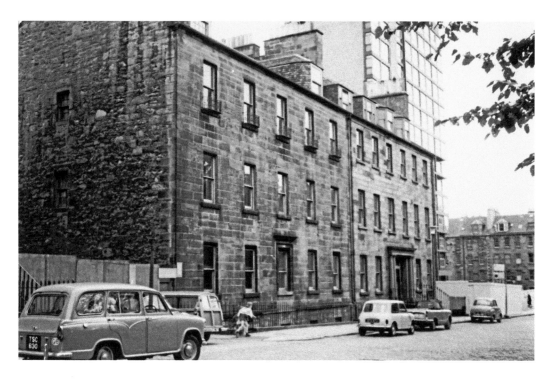

George Square III
The original buildings on the south-west side of the square, which accommodated the Women's Union, were redeveloped for the William Robertson Building, named after a distinguished eighteenth-century historian. The David Hume Tower is in the background.

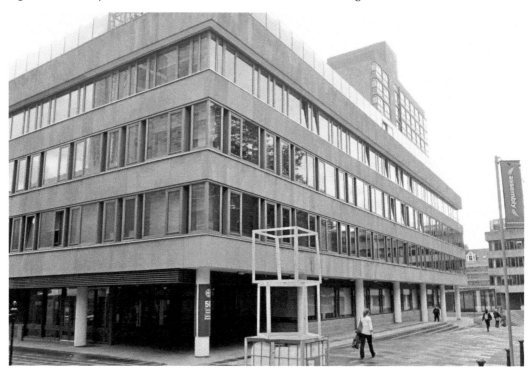

George Square IV

This is the corner of Charles Street and George Square. The old houses were replaced by a building that is now used by the University of Edinburgh's Neuroscience Department.

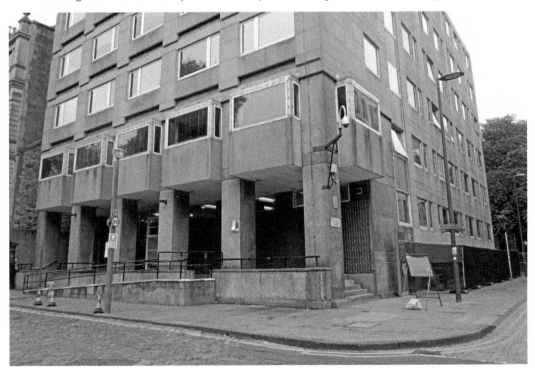

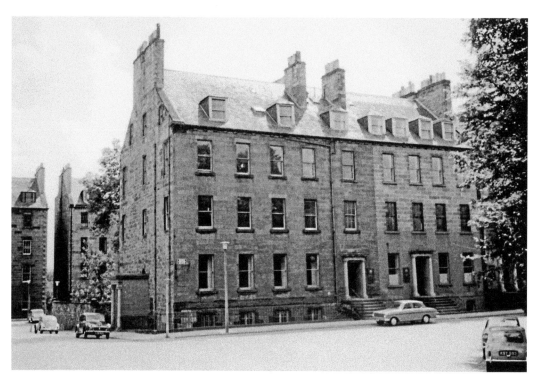

George Square V
The original buildings on the south side of the square were replaced by the Adam Ferguson Building. Ferguson (1723–1816) was an eminent professor of moral philosophy.

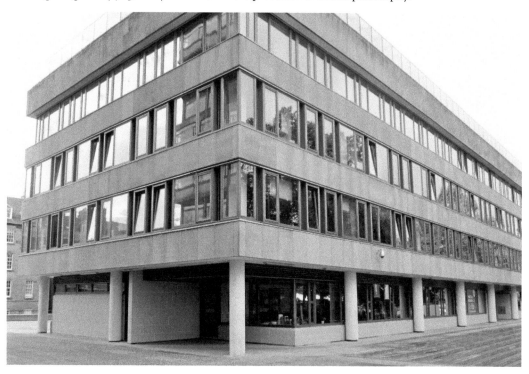

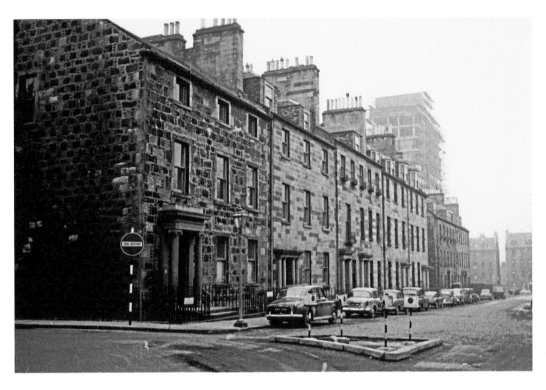

George Square VI

A short terrace of original buildings remain at the entrance to George Square from Charles Street/Crichton Street. The more recent image was taken during the Edinburgh Festival, when the central gardens at George Square are a major venue.

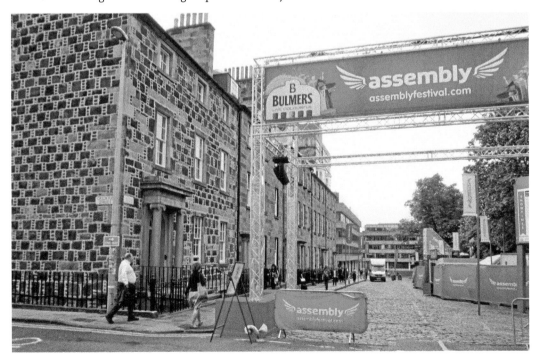

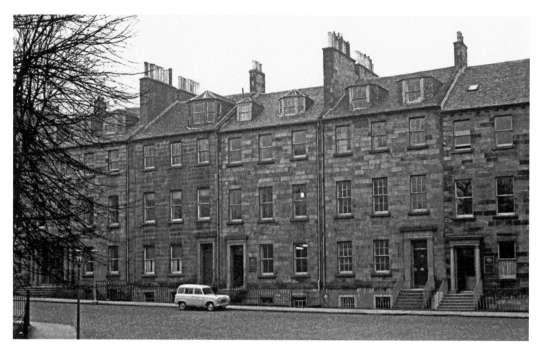

George Square VII

The University Library building on George Square was designed by Sir Basil Spence. This location was selected as the quietest part of the Square. The library is recognised as a major work by Spence and its category 'A' listing denotes its national importance.

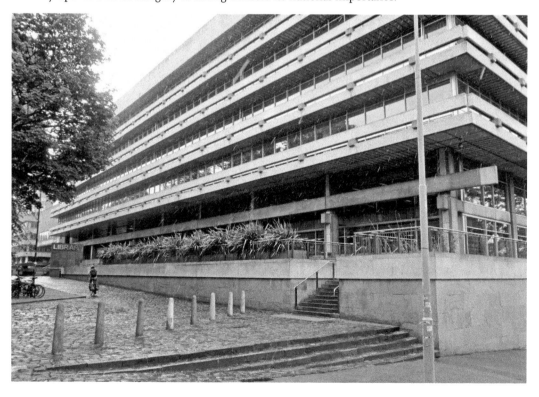

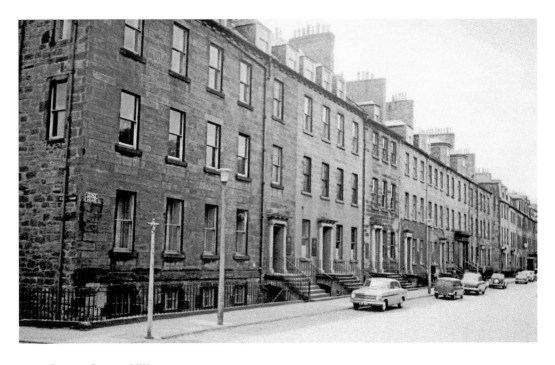

George Square VIII

These images show the south side of the square where the terrace of original buildings was replaced by the George Square Theatre and University Library.

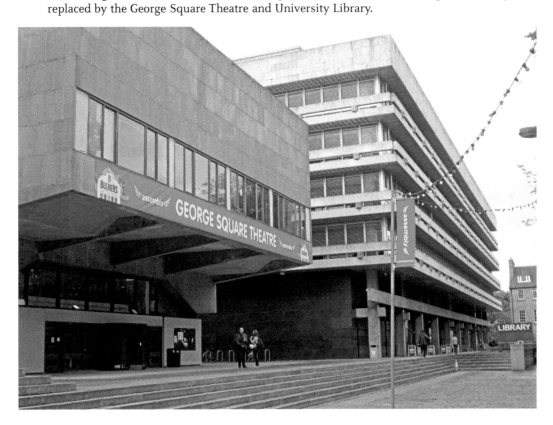

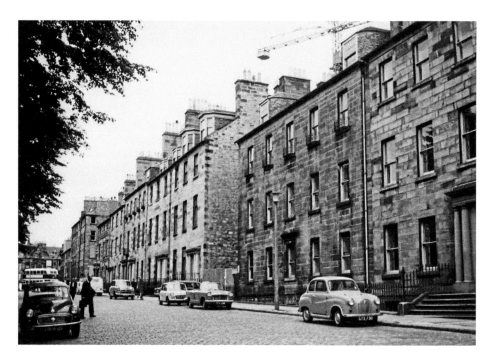

George Square IX

These images show the east side of the square looking out towards Bristo Square. The street that runs between the buildings in both images is Windmill Street, which still connects the Square to Chapel Street. The name refers to an old windmill that was located near the site of Buccleuch Parish Church. It was used to pump water out of the Borough Loch for use in local breweries.

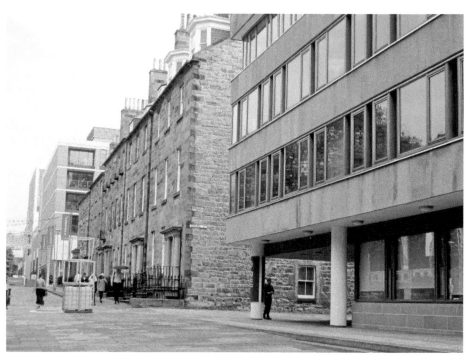

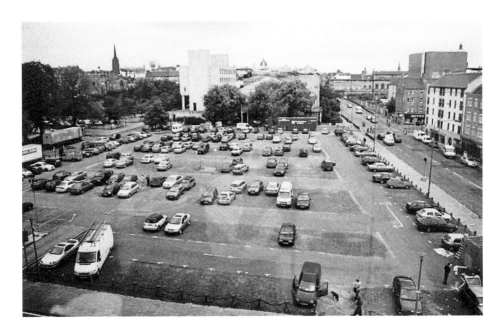

Bristo Area

These views of the Bristo Area are looking north from Appleton Tower. The university's expansion plans resulted in the redevelopment of all of the old buildings between Lothian Street to the north, Crichton Street to the south, Potterow to the east and Charles Street/ Bristo Street to the east.

The northern section was the first to be redeveloped with a new student union. The southern section was used as a car park for many years before being redeveloped for the University's Informatics building and more recently the Dugald Stewart building.

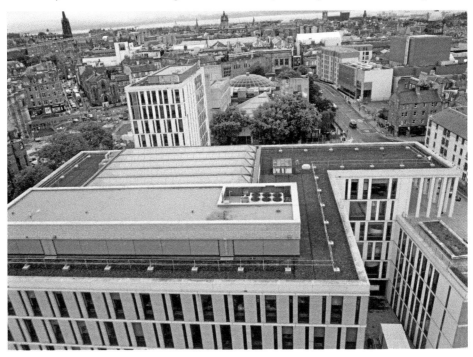

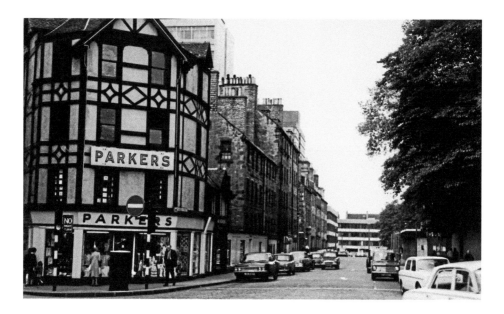

Parker's Stores

Parker's Triangle was the name associated with the tenement block formed by Bristo Square, Crichton Street and Charles Street, which stood between the present Appleton Tower and Bristo Square. The Triangle took its name from Parker's Stores, which occupied a building with a distinctive mock-Tudor half-timbered frontage – a thin cladding added to the old stone facade – at the corner of Bristo Street and Crichton Street. It was a popular haberdashery and many Southsiders of a certain age will remember being fitted out for their school uniforms in the shop. The buildings were cleared in 1971. The triangle had been built in 1770–80 by James Brown, who also developed George Square.

Crichton Street, Appleton Tower

The Appleton Tower was completed in 1966. It was the early stage of a much more extensive development proposed by the university that would have covered much of the South Side. It was intended that the tower would link with university buildings on what became the Crichton Street car park, following demolition in the 1960s. These proposals were abandoned and the car park was not developed until the University Informatics building was built in 2007.

The tower was named for Sir Edward Appleton, who was Principal of the University and one of the main proponents of the university's expansion plans. Windmill Lane, which linked Crichton Street and Buccleuch Place, was lost in the development.

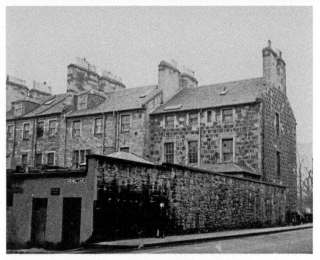

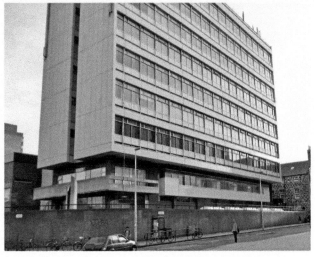

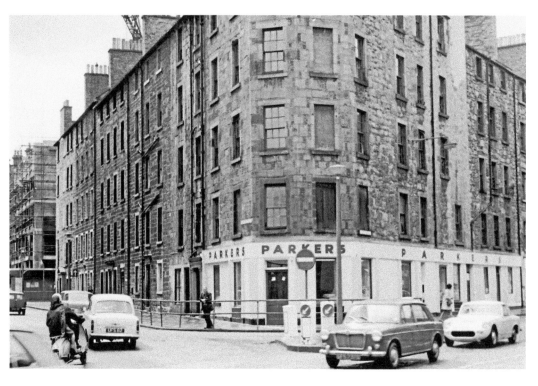

Bristo Street/Crichton Street

The older image shows the southern end of Bristo Street at its junction with Crichton Street. The shop on the corner in the older image was Parker's Carpet Department

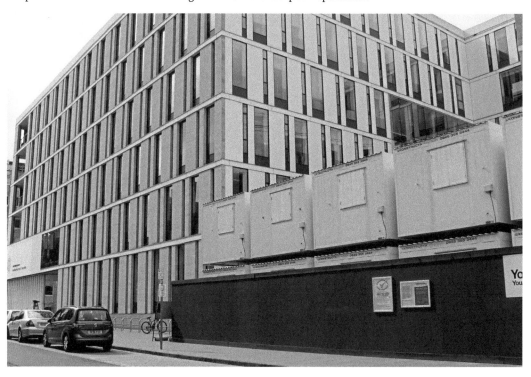

Crichton Street

These views are looking east on the north side of Crichton Street opposite Appleton Tower from the corner with Charles Street.

The building with the rooftop urns in the background of the older image is Chapel House. It is now located behind the mosque on Chapel Street and forms part of the original Mosque Kitchen. Chapel House dates from the mid-eighteenth century and was originally four storeys high. In 1840, it was purchased by Andrew Melrose, founder of the famous Melrose & Co. Tea and Coffee Merchants. On the death of Melrose in 1855 the house was used by the Edinburgh Royal Maternity Hospital until 1870. The celebrated Professor James Young Simpson, who first made use of chloroform in childbirth, was one of the trustees of the lying-in hospital at this time.

The King Fahd Mosque and Islamic Centre opened in 1998.

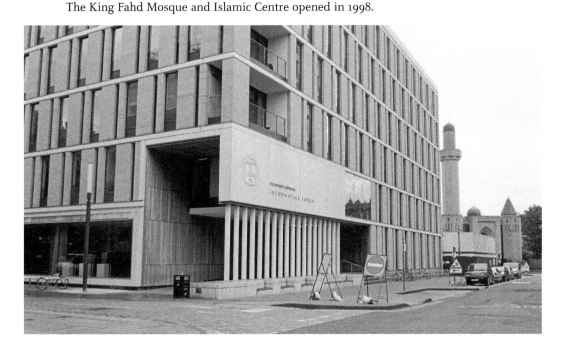

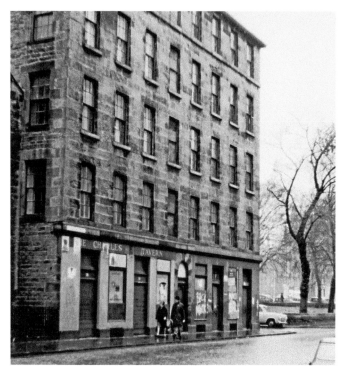

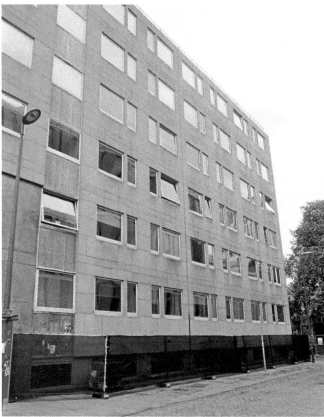

**Charles Street,
Charles Tavern**
These are views along
Charles Street looking
towards the present-day
Bristo Square. The
Charles pub was another
fatality of the university
redevelopment – there were
a lot of pubs in the area
serving locals and students.

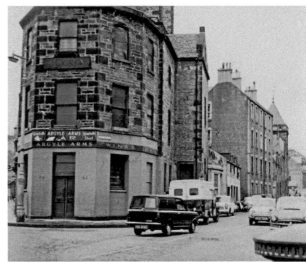

Argyle Arms, Potterow/Bristo Street

This is the corner of Bristo Street and Potterow viewed from Chapel Street. The Argyle Arms was another popular local pub. The building that the Argyle Arms occupied was originally a mansion house known as Dalrymple House until 1813. It was also known locally as the Ace of Clubs because of its unusual shape.

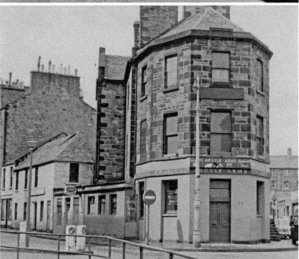

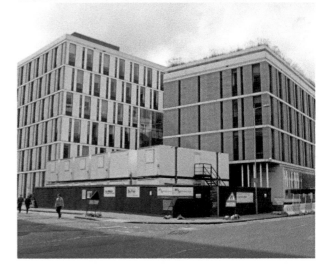

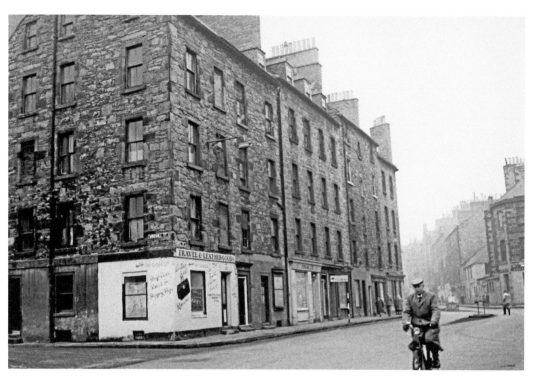

Chapel Street

These views are looking north on Chapel Street. The original tenements were demolished to make way for the Appleton Tower.

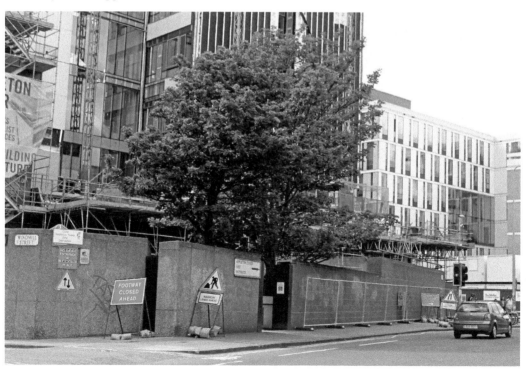

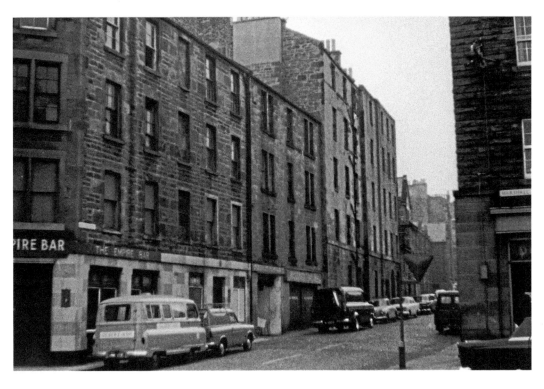

Potterow/Marshall Street

These views are looking north on Potterow. The Empire Bar was on the corner of Potterow and the now lost westward extension of Marshall Street.

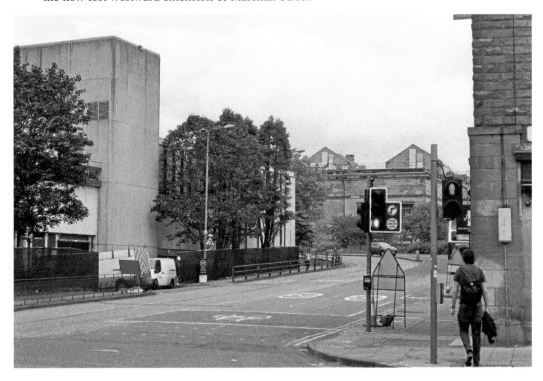

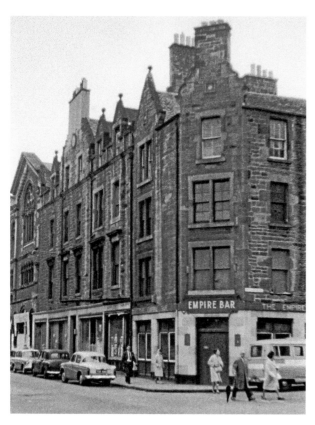

Marshall Street/Potterow
These views are looking along
the original westward extension
of Marshall Street towards Bristo
Square. The ornate building in the
background of the older image
was the Barrie Theatre.

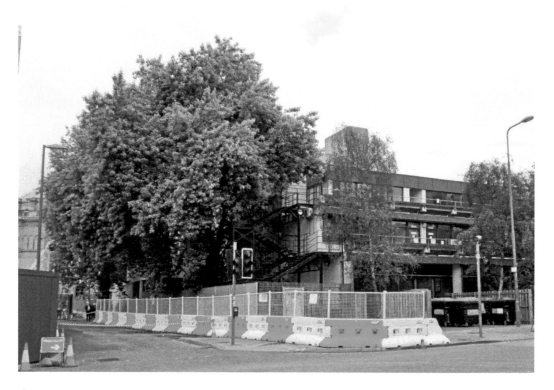

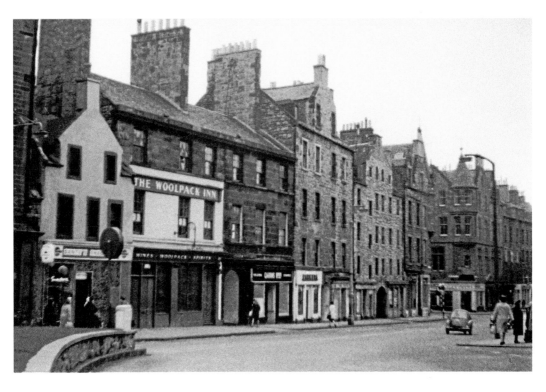

Bristo Street

Bristo Street ran from the corner of Crichton Street and Potterow through to Bristo Place. This part of the street was opposite the McEwan Hall.

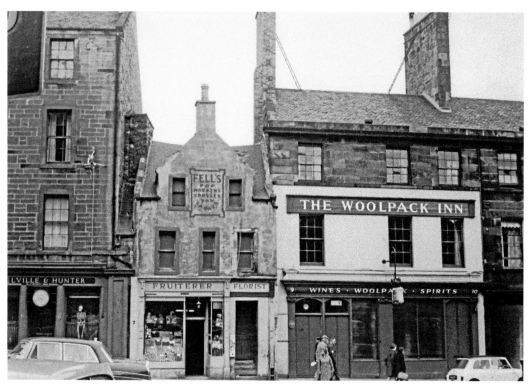

Bristo Street, The Wool Pack Pub and Dante's Café

These are details of the shops on Bristo Street. The Wool Pack pub was a renowned local South Side hostelry. Also note the skeleton, which was a feature of the window display of Melville and Hunter's shop for many years – they supplied equipment for students at the nearby Medical School. Dante's Café was run by Dante Lannie, a well-known South Side personality.

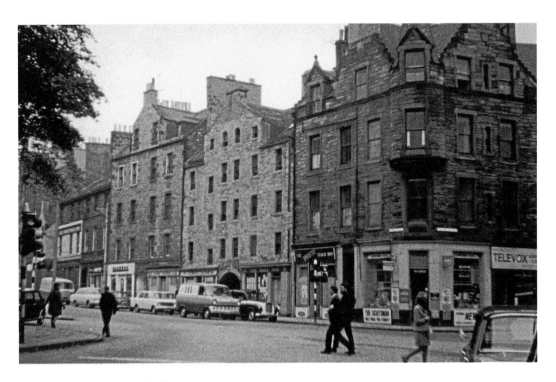

Bristo Street/Marshall Street

The older image shows Bristo Street and the corner of Marshall Street, which originally extended west of Potterow. Marshall Street was the site of one of the bombs dropped from a German Zeppelin raid on 2 April 1916. There were six fatalities on the street from blast debris from the bomb, which landed on the pavement.

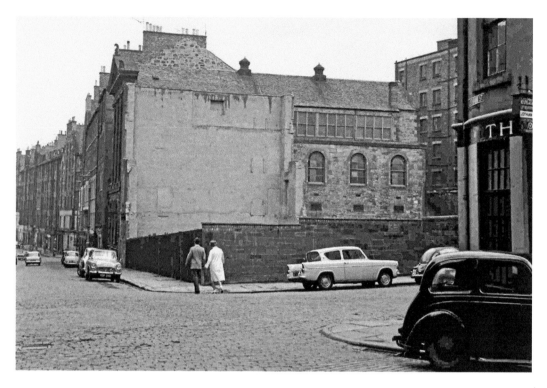

Lothian Street/Potterow

These views are from Lothian Street looking towards South College Street. John Logie Baird, the inventor of the television, had a workshop in a tenement building, which still exists on the north side of Lothian Street.

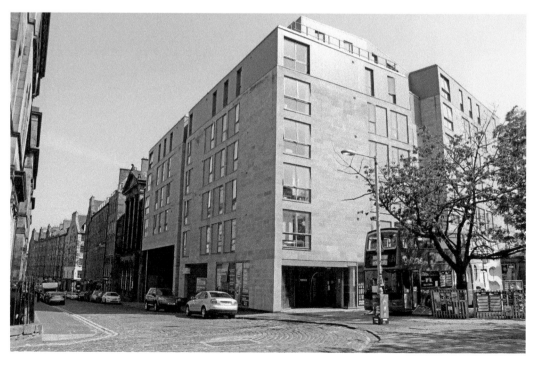

South College Street
These views are looking west along South College Street with the rear of the Chambers Street Museum in the background. The building with the pediment and ornate ground-floor window surrounds dates from 1856 and was built as the United Presbyterian church. The building was converted to offices for the university in 1990.

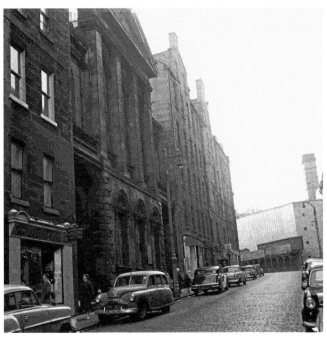

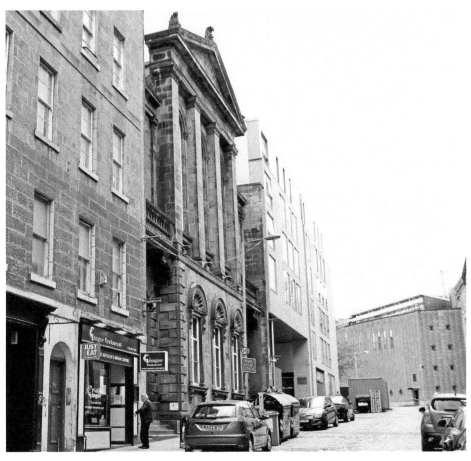

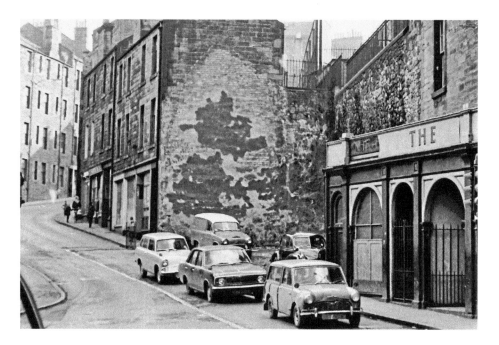

The Pleasance

These are views from the Cowgate looking south to the Pleasance. The tenements in the older image are hard up against the Flodden Wall. Edinburgh was historically protected by a wall on three sides and by the Nor' Loch to the north. An earlier King's Wall enclosed a small portion of the current Old Town. This was extended after the defeat of the Scottish Army at the Battle of Flodden in 1513.

The name, the Pleasance, derives from the Scots *pleasance*, meaning a park or garden, which was the name of a sixteenth-century house in the area.

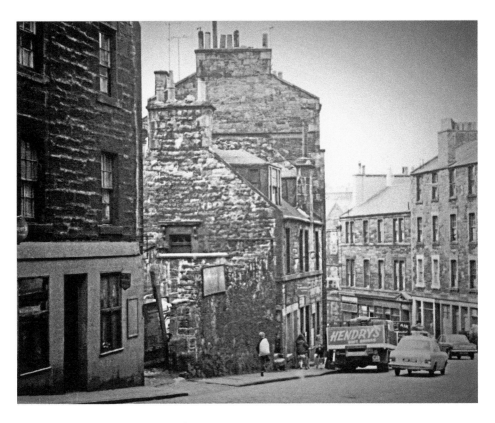

The Pleasance from Drummond Street
A much-changed view looking north on the Pleasance from Drummond Street.

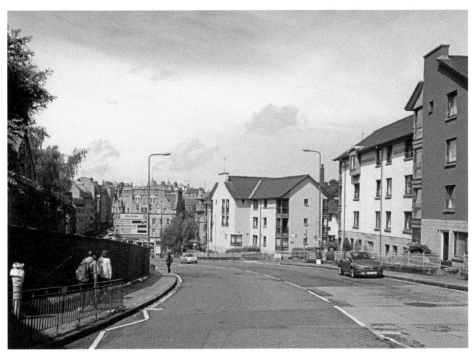

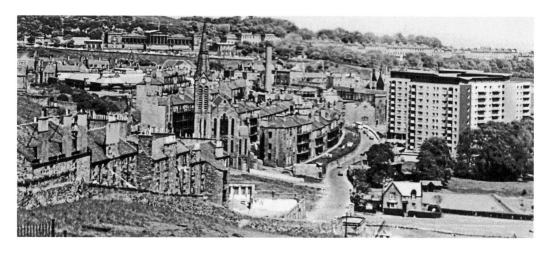

View over Dumbiedykes

Dumbiedykes takes its name from Thomas Braidwood's Academy for the Deaf and Dumb, which he established in a house on the east side of St Leonard's in 1764. The building became known as the Dummie House, from the Scots *dummie*, a dumb person. So, the correct pronunciation of the name is Dummidykes. The Dummie House was demolished in 1939.

Beaumont Place in Dumbiedykes included the 'Penny Tenement', whose owner tried to sell it for a penny in 1953 to demonstrate the burden on landlords caused by rent controls. No one came forward with a penny and on 21 November 1958 at 5 a.m., part of the building collapsed, fortunately with no fatalities.

The collapse of the 'Penny Tenement' focused attention on Edinburgh's slums. Two extensive clearance areas around Carnegie Street were declared and 100 families were moved from dangerous homes and rehoused – the beginning of a major slum clearance drive. In the early 1960s 1,030 houses were demolished in the St Leonard's area and an estimated 1,977 people displaced. St Margaret's Church in the older image was another fatality of the redevelopment.

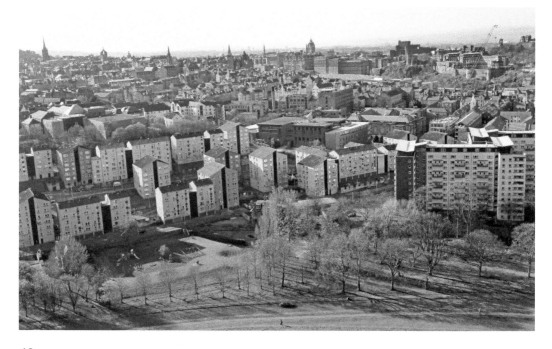

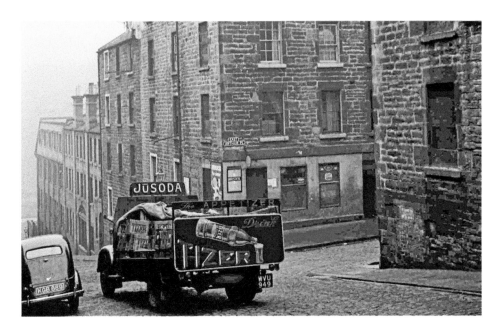

Arthur Street/East Arthur Place

Arthur Street was a steep road running from the Pleasance down to Dumbiedykes Street, which ran along the edge of Holyrood Park. A short section of the original Arthur Street at the Pleasance is now called New Arthur Place and retains its cobbled road surface. East Arthur Place was one of three streets, along with West Arthur Place and Middle Arthur Place, that ran south from Arthur Street.

The 'juice' lorry advertises Jusoda and Tizer. This was a time when juice bottles had a returnable deposit and they were the equivalent of glass money for kids – collect enough and a free bottle of your favourite juice was secured.

The street plan of the Dumbiedykes area was radically altered by redevelopment and the following images include mainly older images of the area.

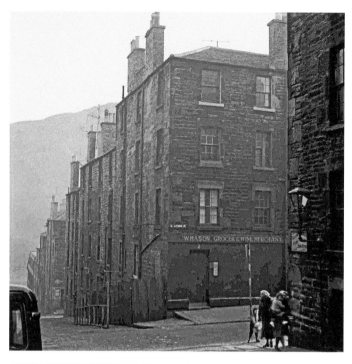

Arthur Street/West Arthur Place

The tenements in the Dumbiedykes area dated from the early part of the nineteenth century. The pub with the van parked outside was the Crags (*see* below) at No. 7 Arthur Street, immediately opposite West Arthur Place (*see* above).

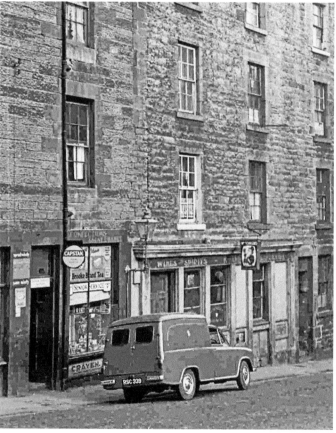

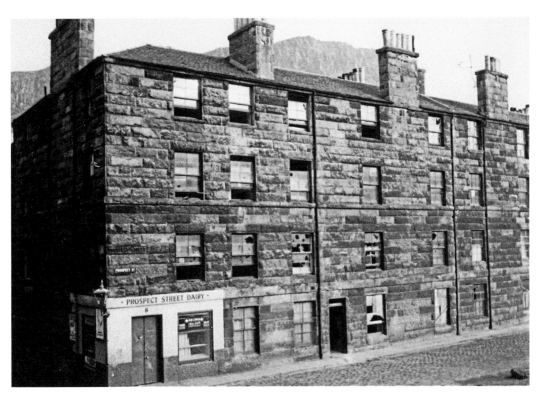

Arthur Street and Prospect Street

Prospect Street (*see* above) ran north from Arthur Street just before it joined Dumbiedykes Street to the junction pictured below. Salisbury Crags can just be made out in the background of the view of Prospect Street, with the Prospect Street Dairy on the corner. The J. Aikman shop was a grocery store on the corner of Arthur Street and Dumbiedykes Street.

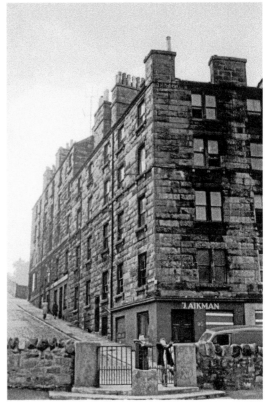

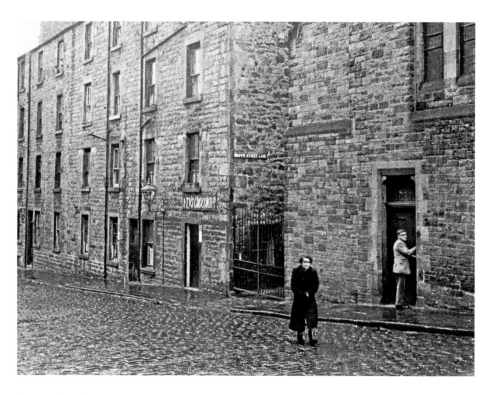

Brown Street

Brown Street ran east from the Pleasance opposite West Richmond Street and still exists as a street. Brown Street Lane ran south of Brown Street to the rear of the former Charteris Memorial Church, which opened in 1912 and is now the Greyfriar's Charteris Centre. The gentleman in the older image is entering the side door of the church.

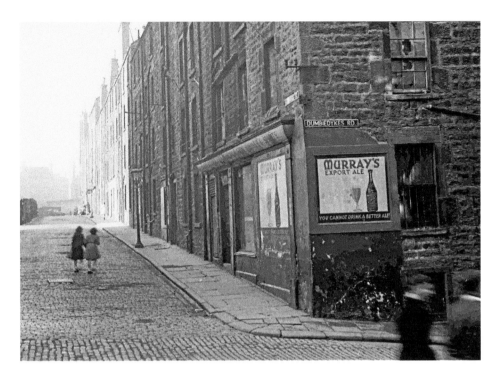

Carnegie Street

These images show the junctions of Carnegie Street with Dumbiedykes Road (*see* above) and St Leonard's Hill (*see* below). The tenements in the Carnegie Street area were demolished in 1959. The pub on the corner of Dumbiedykes Road and Carnegie Street advertises Murray's Export Ale.

Prince Albert Buildings, and St Patrick's School, St John's Hill

The Prince Albert Buildings (*see* above) dated from 1863 and were named in memory of the Prince Consort, who died in 1861. They were in the present Viewcraig Street area of Dumbiedykes and can be seen to the left of the tower block in the earlier long view of Dumbiedykes on page 68. St Patrick's School (*see* below) was on St John's Hill, sandwiched between a sealing wax factory and chemical works.

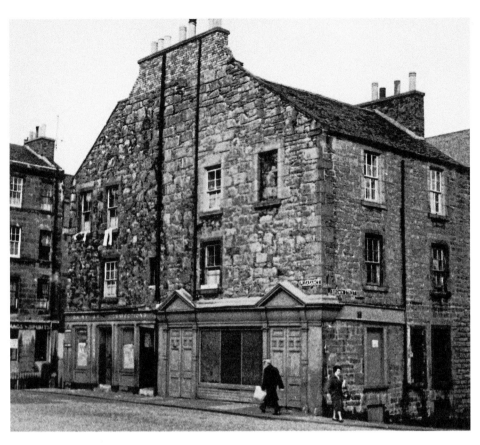

The Pleasance, Brown Street

The building in the older image faced West Richmond Street with Brown Street to the south and Salisbury Street to the north.

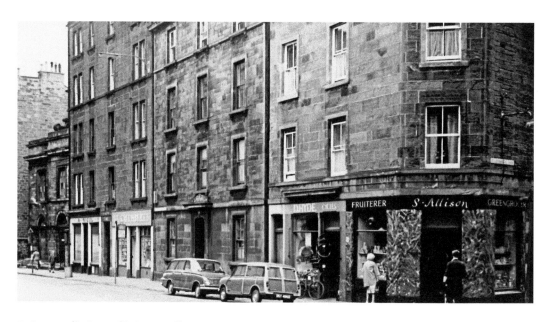

St Leonard's Street/St Leonard's Lane

The group of tenements in the older image was replaced by the St Leonard's Police Station. The building set back from the line of the tenements was St Paul's Free Church.

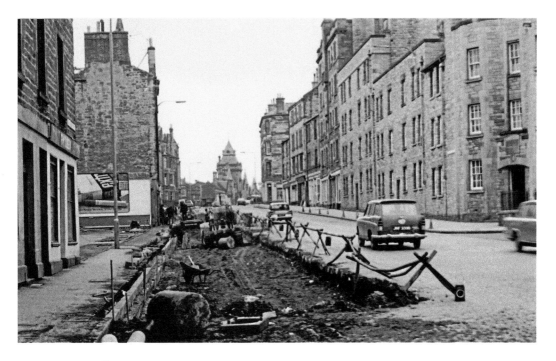

St Leonard's Street

These views are looking south on St Leonard's Street from close to its junction with Bernard Terrace towards Dalkeith Road. Nelson's Parkside printing works, in the distance of the older image, was replaced by the Scottish Widows offices. The buildings on the corner of Bernard Terrace and St Leonard's Street were built as part of regeneration work in the 1930s.

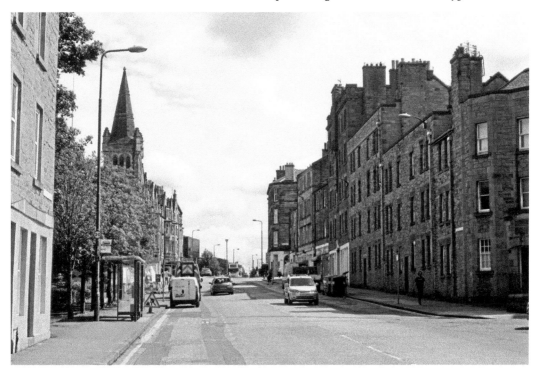

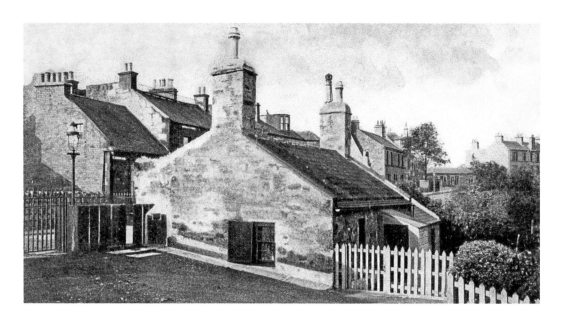

Jeannie Deans Cottage, St Leonard's Bank

This small house at St Leonard's Bank, long known as Jeannie Deans Cottage, was demolished in 1965. Jeanie Deans is the heroine of Sir Walter Scott's 1818 novel *The Heart of Midlothian*. The character of Jeannie was renowned in the nineteenth century for the religious and moral convictions that she portrays in the novel.

The Jeannie Deans Tryste pub at No. 67 St Leonard's Hill has a stone carving above its frontage depicting Jeannie's meeting with the brigand George Robertson at Muschat's Cairn in Holyrood Park.

There is a statue of Jeannie on the Scott monument and there are three pubs in Glasgow named the Jeannie Deans. Jeannie has also had a number of ships, a locomotive, a rose and even a potato named after her.

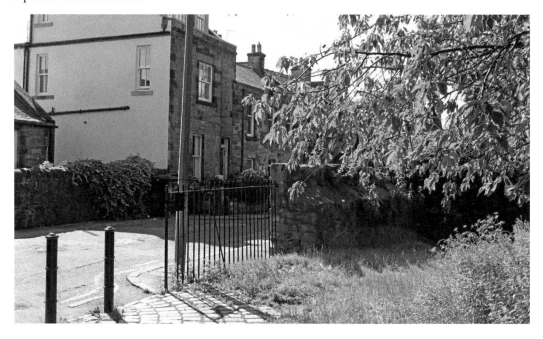

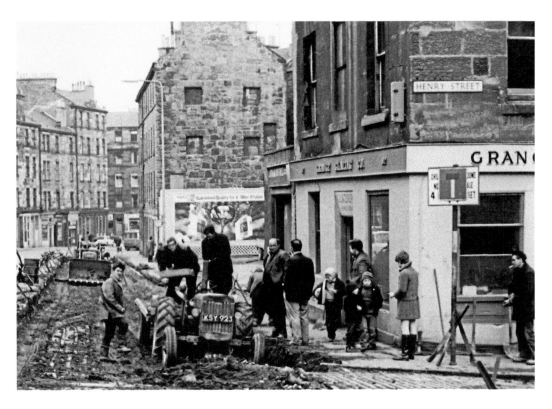

St Leonard's Street/Henry Street

A small group of onlookers are taking an interest in the roadworks underway at the junction of St Leonard's Street and Henry Street. The tenements in the right foreground in the older image were demolished and Henry Street became the entrance to the former Homebase store, which, at the time of writing, is being redeveloped for student housing.

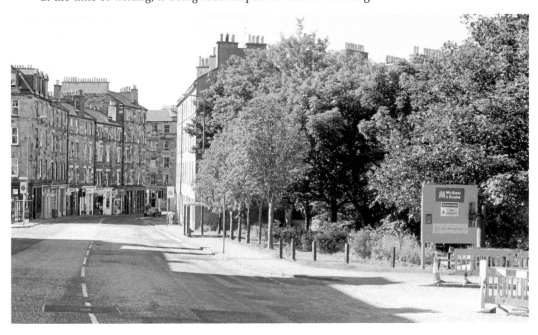

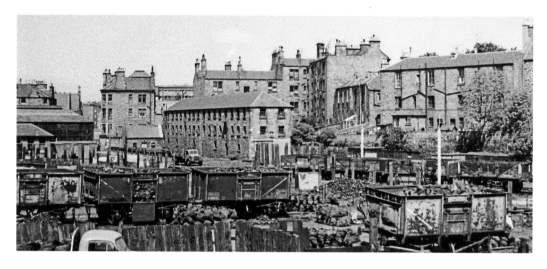

St Leonard's Goods Yard

St Leonards Railway Station served the first rail service between Edinburgh and Dalkeith. The demand for coal in Edinburgh led to the construction of the first railway in the Lothians, when the Edinburgh & Dalkeith Railway opened in 1831. It was known as the 'Innocent Railway', possibly because it was originally horse drawn (until 1846) in an age in which many considered steam engines dangerous. The rate of travel was slow and drivers were warned not to stop and feed their horses between stations.

It was designed by Robert Stevenson and constructed by James Jardine for investors including the 5th Duke of Buccleuch. The line passed through Duddingston, Craigmillar, Niddrie, Newcraighall and out to Dalkeith, although passengers simply jumped off when they reached their destination. The service was a great success, moving over 300 tons of coal a day with a passenger service, started in 1832, carrying a quarter of a million people by the end of the 1830s. The line was bought by the North British Railway in 1845 and is now a cycle path.

The older image was taken when the site was used as a coal yard in the 1960s. It has since been developed for housing. The original engine shed was the Engine Shed Café, which recently closed down.

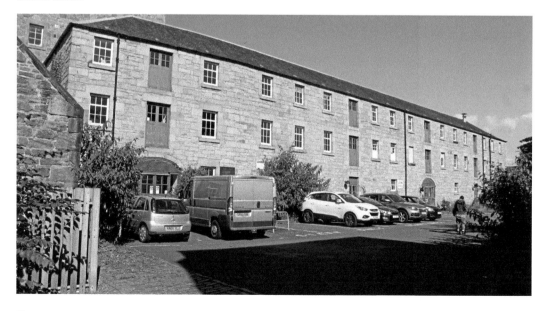

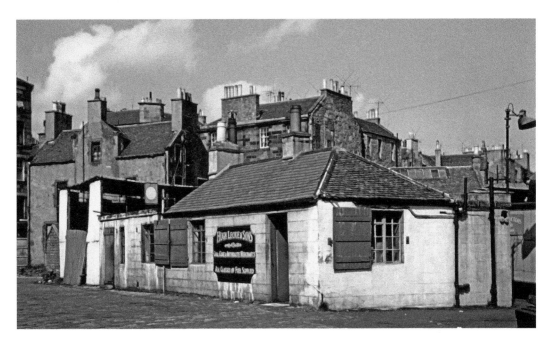

Leckie's Coal Yard, St Leonard's Street

The Leckie coal business opened in 1916 at St Leonard's Station, taking advantage of the rail connection that brought coal into the city. The business went on to become one of Edinburgh's largest coal merchants. Leckie's coal lorries were emblazoned with the company motto 'Grate Expectations' and 'You'll Be Grateful'.

Edinburgh lost its soubriquet Auld Reekie with the passing of the Clean Air Acts of 1956 and 1968. It also spelled the end of the ubiquitous presence of the coalman.

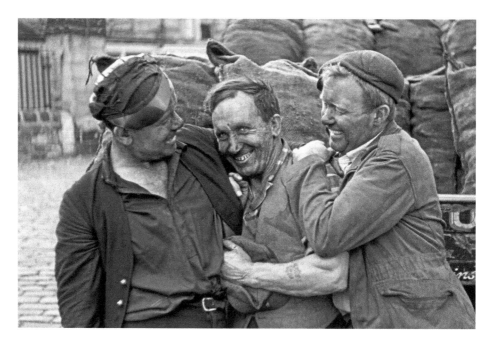

Arthur Street Crash

In times past soot-blackened coalmen were regular visitors to most homes as they heaved huge bags of coal from their flatbed lorry and carried them up the steep stairs of tenement flats. In the South Side it was likely that the coal came from Leckie's.

In 1959 one of the Leckie coal lorries lost control down the steep Arthur Street in Dumbiedykes. A large group of Dumbiedykes' kids descended on the lorry and allegedly ended up with black hands on the day, with the fires in Dumbiedykes glowing a little warmer that evening.

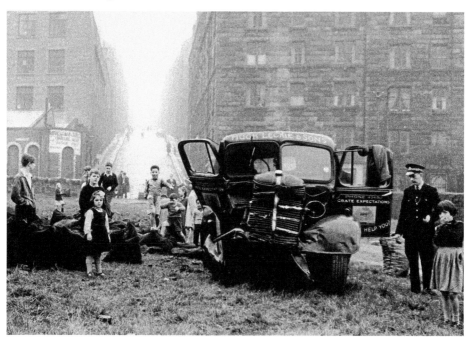

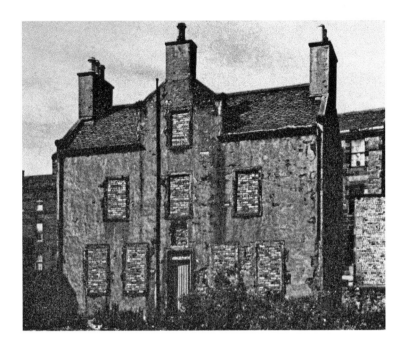

Hermits and Termits, St Leonard's Street

Hermits and Termits, a former country house at No. 64 St Leonard's Street, is probably the oldest house in the area, dating from 1734. The small elegant mansion was built for the solicitor William Clifton in the 1730s. They called the house Cliftonville, but it was always known as Hermits and Termits. The name possibly derives from association with the Abbey of Holyrood (Hermit) and the word for a farm overseer (Termit).

In 1807, the house was occupied by the Edinburgh engraver Robert Scott (1777–1841). Scott's son, William Bell Scott (1811–90), was a renowned artist and poet. The Edinburgh & Dalkeith Railway acquired the building in 1828 and the house was used as accommodation for the stationmasters. The building was vacated in 1968 and fell into dereliction due to road proposals that blighted the area. Hermits and Termits was restored as a house in the early 1980s.

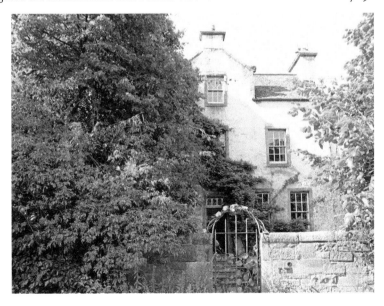

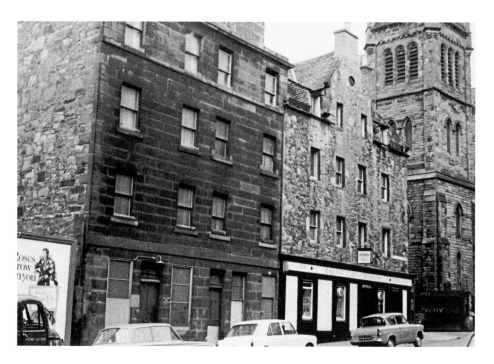

Castle o' Clouts, St Leonard's Street

The quaint-looking tenement next to the former St Leonard's Church in the older image dated from 1724. The ground floor was the Castle o' Clouts, a public house for over 200 years. It was one of the first buildings reached by travellers entering the city by the old road from the south. The story surrounding the name is that it was built by a prosperous tailor named Hunter, and was the Castle of Cloths (Clouts). The recent image was taken when the site was being developed for student housing.

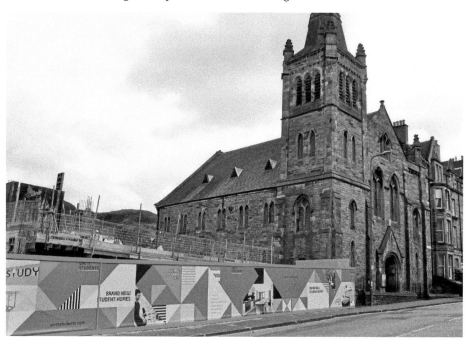

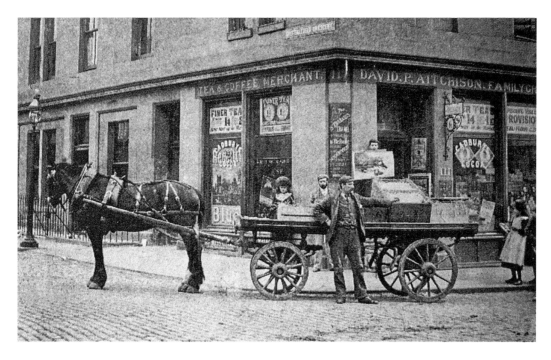

St Leonard's Street/Spittalfield Crescent

The older image shows David P. Aitchison's family grocer's shop at the corner of St Leonard's Street and Spittalfield Crescent. That may well be Mr Aitchison standing proudly in front of his delivery horse and cart.

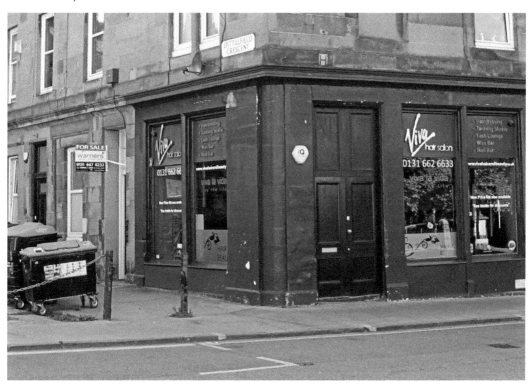

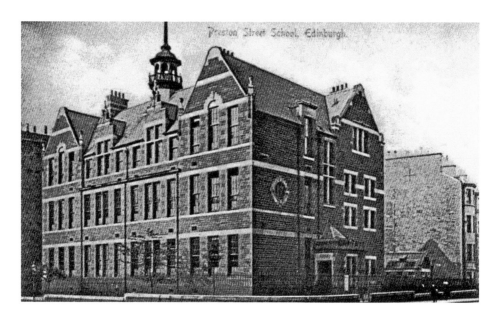

Preston Street School

Preston Street School dates from 1896–97 and is described as being in a Scandinavian-Jacobean style. In the Middle Ages Preston Street was known as Mounthooly Loan; it was the road to the Holy Mount, the site of a small chapel that is now occupied by the Scottish Widows building.

The site of the school has a gruesome history, reflected in an earlier name for Preston Street – Gibbet Loan. During the sixteenth and seventeenth centuries a gallows faced down Dalkeith Road on the site. The mutilated remains of the Marquess of Montrose were buried here, after his execution at the Cross of Edinburgh in May 1650.

The Preston Street graveyard opposite the school dates from 1820. It includes the grave of Jean Lorimer, Robert Burns' 'Lassie wi' the lint-white locks'.

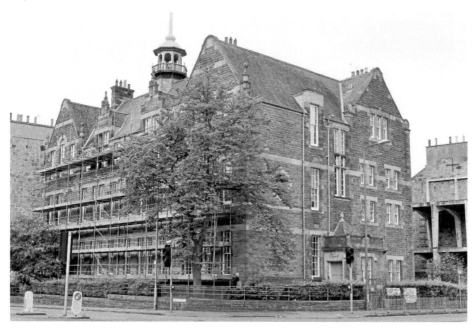

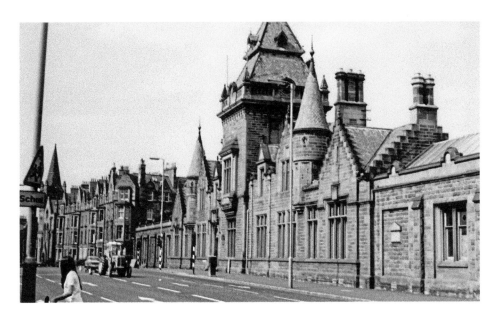

Thomas Nelson's Parkside Works, Dalkeith Road

The Baronial frontage of Thomas Nelson's Parkside Works on Dalkeith Road is shown in the older image. Printing was historically one of Edinburgh's main industries and Thomas Nelson & Sons was one of the biggest. Thomas Nelson opened a second-hand bookshop in Edinburgh's Old Town in 1798 from which he started to publish cheap reprints of classic books. In 1845, Nelson's established a printing house at Hope Park. This building burnt down in 1878 and by 1880 they had moved to the Parkside Works on Dalkeith Road.

In the early part of the twentieth century, Nelson's were the most successful publishing company in the world with up to 400 people employed at their Parkside Works. It was a close-knit family firm and provided a range of social and welfare facilities for its workers, including an institute and a bowling club.

Printing methods remained virtually unchanged until the revolution of off-set lithography in the 1950s, which standardised print production and, as it became cheaper to print abroad, Edinburgh's printing industry almost disappeared. In 1968, the printing division of Nelson's was sold and the Parkside Works were demolished to make way for the offices of the Scottish Widows Insurance Co.

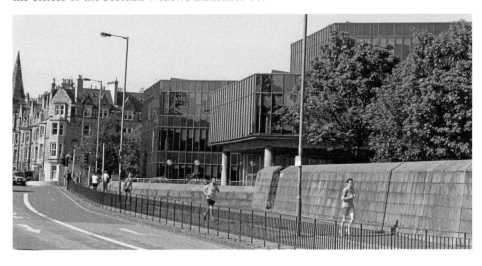

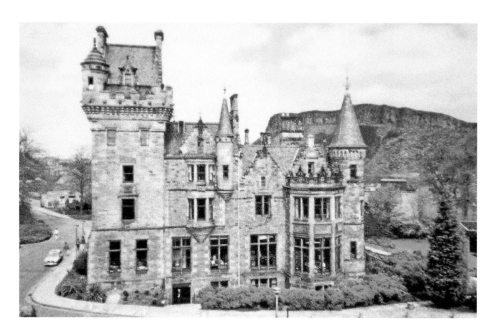

St Leonard's House

St Leonard's House dates from 1869 and was built for Thomas Nelson, the Edinburgh printer and publisher. In 1925 St Trinnean's School moved into the building. The girls' school had been established by a Miss C. Fraser Lee in 1922 at No. 10 Palmerston Road in Edinburgh. Miss Lee ran the school on progressive lines based on self-discipline linked to the freedom to choose subjects. The school moved out to Galashiels at the outbreak of the Second World War and closed in 1946.

The cartoonist Ronald Searle met two of the pupils and was inspired to illustrate their accounts of life at the school, which were published and which inspired the *St Trinnians* films. Miss Fraser Lee wrote a book in 1962 called *The Real St Trinnean's* to set the record straight. St Leonard's Hall now forms part of the University of Edinburgh's Pollock Halls of Residence.

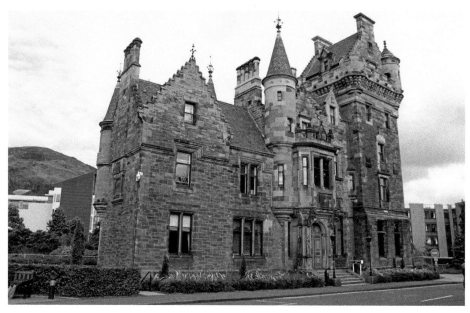

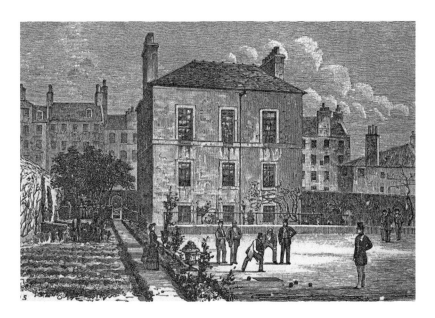

The Archers' Hall, Buccleuch Street

The Royal Company of Archers has functioned as the Sovereign's Body Guard in Scotland since 1822, performing duties at the request of the queen at state and ceremonial occasions. The foundation stone of the Archers' Hall was laid on 15 August 1776 by William St. Clair of Roslin on the edge of Hope Park (now the Meadows), when access to public archery butts was granted by the sovereign. The original building was extended in 1900.

It seems that the Archers were short of cash when the building opened in 1777, and an income was made from the use of the building as a tavern and meeting place for dancing assemblies. In January 1785 the dancing assemblies moved to the George's Square Assembly Rooms in Buccleuch Place and the tavern closed.

Each archer is obliged to equip himself with 'sufficient shooting graith (equipment)' and display in his bonnet the company's seal and arms. Their charter empowers the archers to convene in military fashion and meet 'at least once every year about midsummer to shoot arrows with a bow at a butt'.

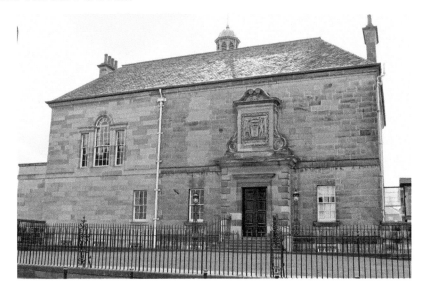

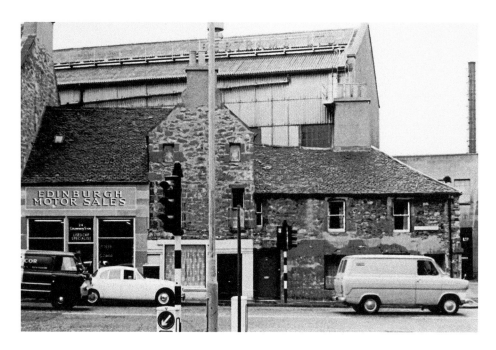

Causewayside

These are views of Causewayside looking from West Preston Street. The buildings on Causewayside were demolished for the construction of new flats in the 1980s. The building in the background was part of Bertram's St Katherine's Engineering Works. Bertram's was an engineering firm that designed and manufactured papermaking machinery. The factory closed and was redeveloped for housing around 1985.

The production of papermaking machinery by Bertram's was closely related to Edinburgh's long history and particular association with printing – contributing to the maxim that Edinburgh was known for the three Bs: Beer, Biscuits and Books.

Causewayside linked Edinburgh to Liberton and it was causeyed in the sixteenth century. Causey is from the Old French '*caucie*', meaning 'a paved road'. So it really should be called Causeyside – as many locals do.

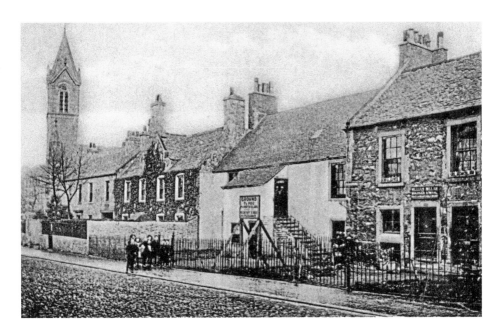

Royal (Dick) School of Veterinary Studies, Summerhall

The Royal (Dick) School of Veterinary Studies (or the Dick Vet, as it is more commonly known) was founded by William Dick (1793–1866), who studied anatomy in Edinburgh and attended the London Veterinary College. Back in Edinburgh he established his own veterinary school – the first in Scotland – at Clyde Street in 1819. A much-respected practitioner, Dick was appointed veterinary surgeon in Scotland to Queen Victoria in 1842. In 1906, the college was named the Royal (Dick) Veterinary College by Act of Parliament.

The college moved to custom-built premises at Summerhall in 1916. Bryson's Brewery, along with the cottages and the United Presbyterian church in the older image, were swept away for the new building. In 2011 the school moved to the Easter Bush campus and the building is now in use as Summerhall, a hub for the arts.

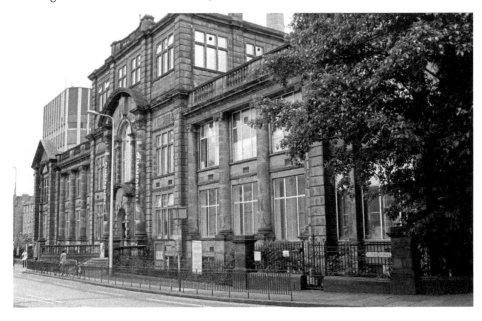

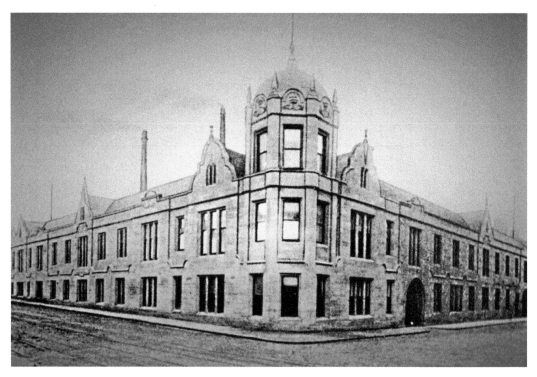

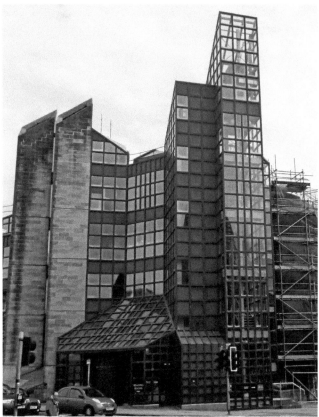

Middlemass Biscuits, Salisbury Place

Middlemass was a noted Edinburgh biscuit manufacturer. The original business opened on the north corner of West Preston Street and South Clerk Street in 1853 – at the time of writing, the premises are a branch of William Hill bookmakers. In 1869, Middlemass moved to a custom-built factory on the corner of Causewayside and Salisbury Place. The factory was redeveloped with a bold new building for the Map Department of the National Library in 1985.

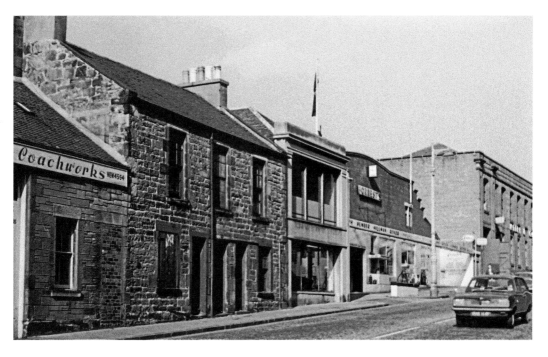

Ratcliffe Terrace

This part of Ratcliffe Terrace has been substantially changed. However, the emphasis on the motor car remains with the County Coachworks and Forrest's Garage replaced by a petrol station and a branch of National Tyres.

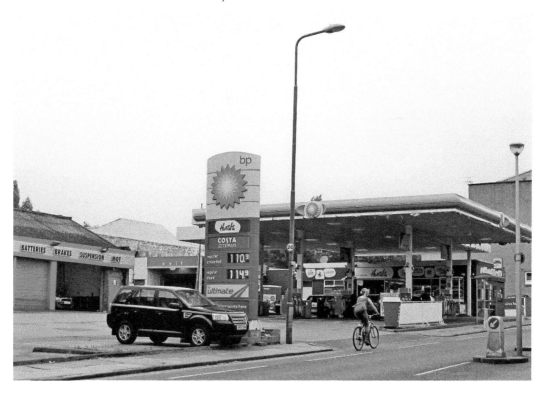

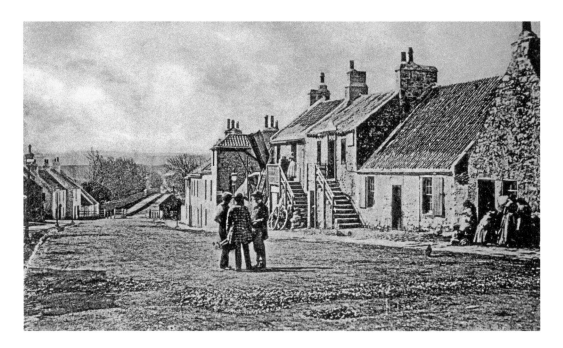

Grange Toll

The older image shows Causewayside looking south towards the Grange Toll. Causewayside formed one of the two main routes into Edinburgh from the south. The other main road was along Dalkeith Road and St Leonard's Street.

Causewayside was an area of handloom weavers with mostly two-storey houses with outside forestairs. From 1850 onwards, the street became congested, unhealthy and disorderly. Barriers were erected at Salisbury Place and Duncan Street to protect the wealthy occupants of the new houses in Minto Street from the rowdy inhabitants of Causewayside. The conditions were so bad that missionary work was carried out in the area.

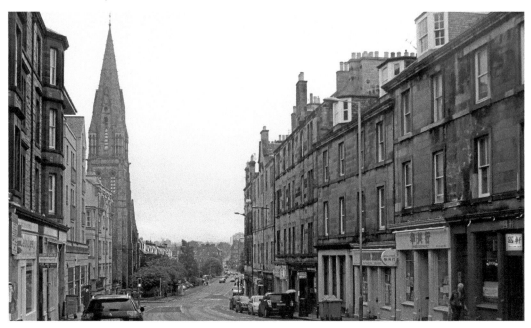

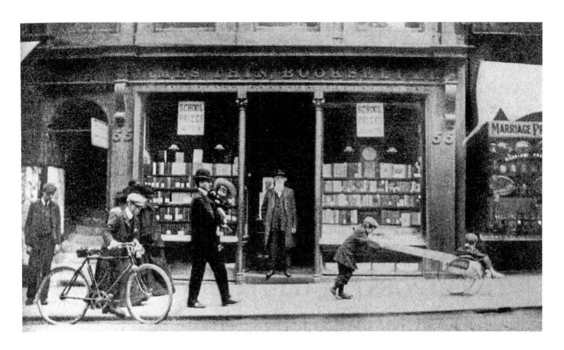

James Thin's, South Bridge

The older image shows James Thin standing at the entrance to his bookshop in around 1900. Many generations of Edinburgh students would have frequented the academic booksellers, James Thin's, on South Bridge opposite the Old College. James Thin (1824–1915) served as an apprentice to a bookseller on North College Street and opened his bookshop at No. 14 Infirmary Street in 1848. The business thrived and Thin's was the main academic bookshop in Edinburgh for 150 years. In January 2002, the historic James Thin brand name disappeared when the business went into administration and was taken over by Blackwell's.

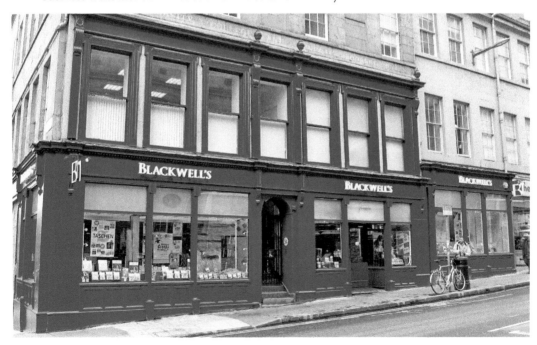

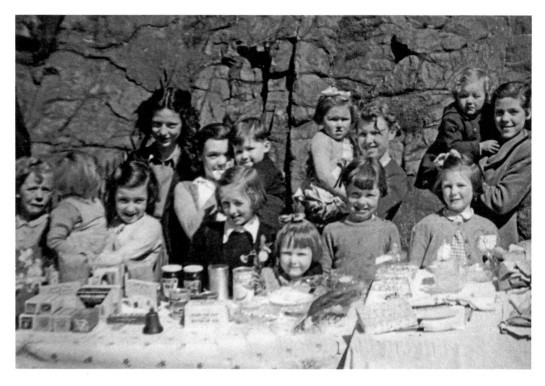

Southsiders at Play

The spirit of community that was a feature of the South Side is reflected in these two images of the Heriot Mount area of Dumbiedykes from the 1950s. An accordion player entertains the crowd during a street party to celebrate the Coronation of Elizabeth II on 2 June 1953, and a group of cheerful South Side kids at an open-air jumble sale stall.

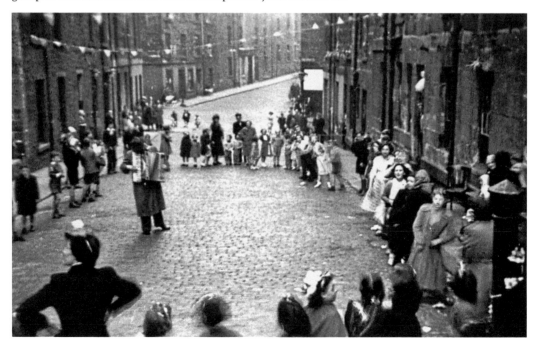